William Casn~~~~~ ~~

A Welsh ~

Memories of the Welsh Colonization in Patagonia

The Welsh Dragon (Yr Draig Goch)
embroidered onto the Argentine Flag

Copyright © E. K. Vyhmeister, 2005

Front Cover: Thomas Davies, farmer on Rawson, circa 1910

FIRST PART

Pioneers of Patagonia

Introduction

The Welsh colonization in Chubut, Patagonia, had distinctive characteristics that converted it into one of the feats of humanity. But, aside from the heroic aspects, we should mention a fact that was essential to the mind of the Welsh. We refer to the care they manifested in leaving consigned in writing whatever was happening. This is a unique case in the history of immigration--at least in Argentina. Due to this, the historians can count on a series of documents produced by the protagonists themselves; this permits the perception and analysis of the actions by the help of ample and reliable documentation. That is why, books of authors such as Abraham Mathews, Lewis Jones and Hubert Humphreys, together with others published recently, are literature classics in this field.

Now one more is being added, that flowed from the pen of Rev. William C. Rhys, and someone may ask if it is not a redundant addition. Of course, part of the information is already available in previous writings and this corroborates the veracity of the sources. But further, there are details large and small that Rhys makes known and that complete the picture in a valuable way. We had the opportunity to verify this even before the book came out of the press. In addition, the point of view of the author differs from that of

others. As he is part of the second generation of actors, he can view the scenario without the pressure of being one of the actors in the drama; and, at the same time apply evaluation and reevaluation.

The intent of his pages not only served to make known the achievements, but also to impulse others to follow the trail; this liberates Rhys from being a cold and distant chronicler. To the contrary, without losing site of veracity, he adds an important dose of reflection, basically implicit, with the continual poetic air that characterizes the Welsh authors, and which, as an example, gave life to the beautiful pages of the Patagonian protowriter, Eluned Morgan.

The studious and readers in general, should thank the children and grandchildren of the author for preserving the original memories, and for their efforts in getting them published. It has been my great pleasure and duty to collaborate and obtain for the first edition, a place in a prestigious Argentine collection. We hope that the English speaking public will appreciate this work, as it merits, that, even though it is quite brief, *is a song to humanity and to God its creator*.

Arnoldo Canclini, The National Academy of History, Buenos Aires, Argentina

Dr. Dr A.Canclini, researcher and author, member of The National Academy of History and former head of the Baptist Church Organization in Argentina.

Prologue

Even while he was a theology university student, William Casnodyn Rhys had his mind set on recruiting to establish a Welsh Colony in some place where they could preserve the Welsh language and culture. Therefore, it was not strange that, a few years later, we find the Baptist congregation of the Chubut Valley Colony requesting this young pastor of the Baptist Congregation of Swansea, Wales, to accept an invitation to be a farmer in the Colony and at the same time be the pastor of the chapel that they were building. They could not promise any wage remuneration, but yes, a farm of 250 acres to cultivate, offered by the Government. Rhys decided to accept the offer, and with his young wife and baby daughter Myfanwy, sailed to Patagonian shores where they began their new home on farm 168 in Treorky, Chubut. From then on, he became part of the Colony that had began eleven years before (1865) in the lower valley of the Chubut river, called *Chupat* by the Tehuelche Indians, and *Camwy* by the Welsh.

For more than 15 years, Reverend Rhys became part of the first colonizers and collected stories and took notes from those who had experienced the hard years of the pioneers. He was able to consolidate various cultural, religious, social, and administrative institutions in the area. When he returned to Wales, in the last decade of the nineteenth century, Rhys decided to divulge the epic of the Welsh Colony of Chubut. At the request of many churches of Wales, he visited most of the Cambrian chapels giving talks and urging others to join the Colony. At the same time, his listeners were encouraging him to write the history of those pioneers. This he did, but the manuscript only reached Chapter

11, there it ended, incomplete. Nobody seemed to know why.

Many years after his death, on my first visit to Wales, I was able to discover the reason for this abrupt ending. A young friend had come from Patagonia and was his guest in Wales. He lent her the manuscripts to read while she was there. But it seems that she copied a good part of them. Some time later she published in Welsh a small book, that as Reverend Rhys read it, he recognized much of his manuscripts. Now he was in a dilemma. What should he do? Expose publicly the plagiarism and shame his friend, when maybe she had done it in ignorance or was not familiar with the code of ethics? Write his book and expose himself to being branded a plagiarist? . . . His decision was Solomonic: he would send the manuscripts to the archives. That is how *Pioneers in Patagonia,* together with the talks *15 Years in Patagonia* and other manuscripts were deposited in the archives of The National Library of Wales. There they lay dormant, unknown to the family, for seventy years.

In 1969, when my daughter Myrtha was working on her doctorate in Geneva, Switzerland, she decided to visit her relatives in England and Wales for Christmas. While visiting her aunt in Cardiff, she found out that her great-grandfather Rhys had dedicated long hours writing his memories for a book that was never published. She was unable to obtain precise indications about the location of the manuscripts, except that they might be in the archives of one of the Welsh universities, maybe Aberystwyth.

Following that trail, the manuscripts finally came to life in the National Library of Wales, under the registry

MS.16.653 and 16.654. A couple of years later I was able to obtain a copy of the memories sent to the U.S. by the Library.

Some years later, a copy of part of the manuscripts was sent to my brother Leslie in Chubut and by chance were read by Dr. Arnoldo Canclini, Pastor and head of the Baptist Church in Argentina, and a notable author and historian of the first missionaries to the aborigines of Patagonia. Reverend Canclini's keen eye of a scholarly historian and researcher recognized the value of the document, and used his connections and influence on myself and on the publishing houses, until the book was translated into Spanish and published in Buenos Aires in 2001 by Emecé. His insight was right; in less than a year it sold out and a second edition was printed.

The first part of this book consists of the 11 chapters of the unconcluded manuscript, *Pioneers of Patagonia,* which gives the history of the Welsh Colony from its beginning until 1870. In the second part we have selected portions of his chapel talks: *Fifteen years in Patagonia.* This gives the principal events in the Colony up to the end of the XIXth Century. To help the reader establish correlations and grasp the historical period, some appendixes and related photos have been added.

 David Hall Rhys
 Grandson of William Casnodyn Rhys
 Loma Linda, California, USA

Acknowledgments

Through the help of a number of people, this book was made possible, and to them I extend my sincere gratitude. My daughter, Myrtha Rhys Pizarro, discovered that William Casnodyn Rhys had written memories on the colonization of Chubut and gave me the information; then the National Library of Wales provided me with the documents that were under their custody and authorized their reproduction. My wife, Adela, who typed the original documents. My brother Leslie (now passed away) who translated into Spanish the greater part of the *Memorie*. Leslie's sons, Milton Rhys, who researched the related documents that were available in the Colony in English, Welsh, and Spanish, and Roger Rhys, for his many photographs of the Patagonian fauna. My daughter Nidia Rhys Vyhmeister for her technical help computerizing text and photos for printing. My grandson E. K. Vyhmeister for publishing this book. Professor Clydwyn Ap Aeron Jones for his article on the Eisteddfod, Appendix II. Dr. Arturo Roberts editor of NINNAU, Cathrin Williams, and Evan L. Dobson for the article and photos related to the unveiling of the plaque in honor of Michael D. Jones' at his birthplace in Llanuwchllun.

I wish to highlight the contribution of Dr. Arnoldo Canclini, member of the prestigious National Academy of History in Argentina, researcher and author of numerous books on Patagonia, also former director of the Baptist Library in Buenos Aires and head of the Baptist Church Organization. His keen intellect foresaw the historic and cultural value of the documents, and with untiring counsel and orientation inspired and guided the efforts till its realization.

There are many more that merit mention, but because of space I will only name three granddaughters and one grandson of Rev. Rhys in three different continents that patiently checked old family photographs and identified the persons needed. They are: Olwen Rhys Ballentine of North Wales; Lesta Rhys Calvo of Argentina; Marion Thomas of the Isle of Wight, and Lewis W. Rhys of England.

D. H. R.

Biographical Sketches

William Casnodyn Rhys was born in 1851 in Tai Bach, Port Talbot, Wales. His parents were David Rhys (also Rees) and Mary Morgan. His primary and secondary studies were received in the local schools of Wales. He studied theology in a Baptist Seminary in Pont y Pwl and received his degree in theology. To pay for his studies he worked as pastor of the Anglican Church at Pennar, in Pembroke Dock. This contributed, without doubt, to broaden his religious criteria and help him lose the narrow concepts so common in religious leaders of the time; it also gave him greater means of collaborating with different Christian denominations as he demonstrated many times later in life.

In 1876 he married Frances Margaretta Stephens, born in Hereford (England) who faithfully accompanied him for two years as pastor of the Baptist Church of Penfo, Wales, fifteen years in Patagonia, and her final four years of life in London where Rhys was pastor of the Baptist Church of Stroud Green. Frances passed away in 1896 at the age of 46. Nine children were born to this couple, four girls and five boys. Seven were born in Patagonia, Argentina. They were David Ivor,

Goronwy, Alfred Geraint, Llywarch W., Margaret Mair, Eurgain, and Leyshon Iwan. The eldest, Myfanwy, and the youngest, Olwen, were born in the *"Old Country"*, as they would say.

In 1900 Rev. Rhys was elected pastor of the Baptist Church of York Place, Abertawe, Wales, and there he led the church for 28 years. He retired in 1928, having dedicated 52 years of active service to evangelical ministries.

In 1898 he remarried, to Jesse Myfanwy Castell Evans, the daughter of a notable professor of the University of Wales. To this union were born two girls and two boys: Nell, John, Dorothy Bronwen, and Robert Dochan.

Reverend William Casnodyn Rhys died in his home on Gower Road, Killay, Abertawe, in 1941, eighty-nine years old.

Up to here, the brief biological and chronological data; but for the readers of this book, I'm most certain that their greater interest will be in his cultural and spiritual legacy to the Welsh Colony in Patagonia.

In 1878, upon request from a few Baptist families that were part of the new Welsh Colony in the Chubut Valley of Argentina, but with the clear understanding that there was no possibility of a pastor's wage, William and Frances accepted the invitation, and with their firstborn baby, Myfanwy, sailed for Chubut, arriving in January of 1879. A few months later their second child was born, David Ivor, my father. (He was the only one who returned to the Colony to make it his permanent home).

Rev. Rhys, as a Baptist preacher in that part of the world, made his living behind the plow on Farm 168 given to him by the Argentine government; he preached every Sunday in the first Baptist church recognized by Argentina as its legitimate denominational property. The chapel was located in Drofa Dulog, on the north bank of the Chubut river, on a section of land from farm 126, donated by a faithful Baptist, William Rees, one of the first Settlers of the Colony and the first to be baptized in the Chubut River (by R. M. Williams). Possibly the location of the church had to do also with the commodity of a close baptistery, the river. As is well known, the Baptists follow faithfully the biblical instruction and the example of Jesus, baptizing all members by total immersion. Next to the church, as was the custom in Europe, there was a humble, but well-kept cemetery. Some of the names of the members, such as D. Rhys Thomas as church secretary; David Thomas, James Harris, and William Rees as deacons, have been preserved due to a written testimony of thanks given to Rev. Rhys when he was offered a good-bye recognition party on May 29 of 1893 before his return trip. The disastrous flood of 1899 washed away this beautiful little church, together with its cemetery.

The literary and cultural capacity of W.C. Rhys had come to public attention already when he was a young pastor in Wales. At 25 he was a noted young poet (a *bard,* as they were then called) and competed in the *Eisteddfods* (national yearly contests in poetry, music, songs, and arts). Three years before emigrating to Chubut he won the *Bard's Chair,* the trophy of highest honor in poetry. With his first triumph, the bard receives a new name of honor conferred on him to be used from then on, especially for his compositions.

Rhys was given the name *Casnodyn*. In Chubut he was most known as W. Casnodyn Rhys. This explains why, very soon after his arrival in the Colony, he was selected to chair the committee that was to promote and organize the *Eisteddfods* in the Valley. Also he was elected president of *Camwy Fydd (*Chubut of the future), an entity that was to be in charge of organizing the Exposition (shows) of Agriculture. Although a local *Eisteddfod* had been held in Glyn Du chapel in 1875, the first general competition for the whole Colony was held in Trelew, in the same big shed where the Agriculture Show was functioning. This circumstance pasted a lasting name on that first competition: *"The Eisteddfod of the Cabbages"*. A couple of years later Casnodyn won his second Bard's *Chair*. This chair is in exposition in the Gaiman Museum of History. The poem bore the title of "The Cemetery" and had 21 verses.

Even though the *Eisteddfod* was held only once a year, the preparation for the event was a continuous activity in the chapels of every denomination all the year round. Choir practice, music, recitation--all pulsed to the beat of the *Eisteddfod.* This cultural emphasis through yearly contests has transcended the limits of Chubut and has exerted its influence in the education of all Argentina, especially at the level of secondary education. Today similar contests are applied in the high schools of all the provinces. Then the top candidates of every province compete at the national level. Generally, the winners are prized with a tour of a specific area of Europe.

As the subject of this biography had university preparation, a position not very common among the members of the Colony, he was continually required for

activities neither of a pastor nor of a farmer. As an example, we find him in 1885 as secretary of the first Municipality of Chubut, in the town of Gaiman. This was the first municipal council in the whole country. This motivated the National Law N. 1.532. He was requested to write the details of its organization and the pertinent by-laws. Because he had certain knowledge of Spanish, although very limited, yet ahead of most of the others of the Colony, he was requested to write all the official minutes in Spanish and in Welsh. Many of these are still in the archives today. When the president of Argentina, Julio A. Roca, visited the Colony he manifested his interest in studying the structure of the Municipality of Chubut. Later, when W.C. Rhys passed through Buenos Aires on his way back to Great Britain in 1893, according to my Aunt Mair, President Roca came to visit him at his hotel and honored him with a gold medal in recognition for his services.

One of the great objectives that the Welsh Colony of Chubut treasured was to develop a cooperative system to insure the stability of its work and the commercialization of its products. Reverend Rhys had developed an interest in the cooperative approach while a student in Britain; very soon he became the mental organizer of The Chubut Mercantile Cooperative. For more than forty years this was the strongest economic support of the farmers. Before this, the Colony had become aware of the vital importance of uniting efforts to develop and maintain the needed infrastructure for the irrigation of their farms. Rhys built on this concept and promoted the strengthening of the Irrigation Cooperative by widening and extending the main canals that would feed the local farm ditches with the required irrigation water.

During the last part of the 19th century many of the Colonists became interested in developing new settlements in Chubut. After a long wilderness trek of more than six hundred kilometers to the West, young Welshmen had discovered the great Andes Range and some of its beautiful valleys. They were lured by the scenery and the agricultural possibilities, and began developing a new Colony which very soon became the most prosperous. They called it *Cwm Hyfryd (*beautiful valley), later, it was officially named "Colony October 16". It didn't take long for W.C. Rhys also to get interested in this valley, and the Argentine government awarded him half a league (1250 hectares) in the new settlement, but his return to England impeded any plan for development.

The solving of the education problem, especially at the post-primary level, was one of the dreams of the Colony for its children. Together with a young teacher educated in England and Wales, Miss Eluned Morgan, they worked on the project of establishing a secondary or intermediate school in Trelew and Gaiman. In 1890 the Intermediate School for Girls opened its doors in Trelew under the leadership of Eluned. Rhys presided the Examination Committee. The Gaiman project did not crystallize until some years later when the *Ysgol Ganolraddol y Camwy* (also called The English Intermediate School) was founded. A unique tri-language institution, some subjects taught in English, some in Spanish, and some in Welsh. For many decades this institution decidedly influenced the education in the Valley. Although restructured into a Secondary School, this house of learning still functions in Gaiman.

Some of Casnodyn Rhys' interests are somewhat unique and even curious. He developed a handbook of shorthand, long before Pitman or Gregg developed their well-known manuals. He also invented an international language on a similar basis as Esperanto. We received information that he also wrote some treatises on theology, but up to now, they have not been located.

Although I never had the privilege of getting to know my Grandfather, let me end with an incident that made me visualize him as an octogenarian. Nell, his daughter, had given me the address where he had passed the last decades of his life. I was visiting Wales, so I drove to Abertawe and began searching for Gower Street. I found the street, but not the number 421 or the house. As it was late afternoon, I got out of my car and began searching for the number from the sidewalk. An old lady sitting in front of her house on the opposite side of the street was observing, and called to me, "Sir, are you looking for something? May I help you?" "Yes," I replied, "I'm looking for the number 421, where my Grandfather lived more than 30 years ago". "Oh, Reverend William Rhys!?" "Yes, that's him!" And without saying more, she called her elder sister from inside who came out to see what it was all about. "This man is looking for the house where old loving Pastor Rhys lived." Then she pointed to a clump of trees on an elevation near the middle of the block, "that's where he lived." "Were you acquainted personally with him?" "Of course," said the elder sister, "every morning, early, he would go for a walk with his small daughter, and we would run to him to listen to the marvelous stories about nature that he would tell us. In summer it would be before the sun was up, he would cross the open fields, that are no more now, and then suddenly stop and say to us, 'Listen, soon the lark will

sing, when the sun rises'. After sunrise he would show us where the other birds were, what their names were, when did they sing. . .and in that way he would teach us to understand and love nature. What a lot did he know about the plants and animals! Who could forget him!" I thanked them, and left full of gratitude. I returned to my car where my wife was waiting, but before I got in the car, I stood and gazed long at that clump of trees, then lifted my eyes to the sky and exclaimed: "Thank you Lord, you have let me finally hear a sermon from Grandpa."

D.H.R.

Rev W.C.Rhys with his first, wife Margaretta Frances Stephens. Circa 1876

The Baptist Pastor, Rev. William Casnodyn Rhys, in his clergy "Frock". This frock has its story. The Reverend was very kind-hearted and in his eighties, liked to visit the poor families. Many times he would give them all the money he carried. So, his wife had to monitor his pockets to avoid "bankruptcy". When he had no more money to give, he would leave his frock for someone to pawn; later he would re-buy it at the pawnshop.

Margaretta Frances Stephens [1849 – 1896]

Picture taken after their return to England and the death of Frances. The eldest daughter, Myfanwy, has Olwen on her lap; they were the only two not born in Patagonia. The others from left: back, David Ivor and Geraint; front, Leishon, Eurgain, M. Mair and Llywarch

Back row from L: Eurgain, Mair, Llywarch. Sitting: W.C.R. with John standing, Jesse Myfamwy (second wife) with Bronwen on her lap, his father David. Sitting in front: Leyshon, Olwen and Nell. 1904 [Dochan was born abt 2 years later]

The Bard's Chair, won by Rev Rhys in the Welsh Eisteddfod of Chubut, for his poetic composition. It is displayed in the Gaiman Museum.

William Casnodyn Rhys' desk that he used in Swansea

PIONEERS OF PATAGONIA

Chapter 1

Brothers Face The Desert

On Sunday May 25th 1865, the sailing Ship "Mimosa" of about one thousand tons weighed anchor on the Mersey with 153 souls on board, bound for a distant destination. The usual valedictory waving and manifestations over, the little band of emigrants resolving themselves into smaller knots had leisure to think, to weep, and to dream. Pleasure was derived in reperusing correspondence from home and friends. One of the literati of the principality of Wales bade farewell to his nephews in words to this effect:

"Since you will not be dissuaded from expatriating yourselves to that wild outlandish desert, I write to wish you a safe and pleasant voyage and much success in your new country. If the Indians do eat you up, I can only wish them a confounded bad digestion."

The Mimosa vessel carried the first contingent of 152 Welsh from Liverpool to Chubut. They arrived on July 28th, 1865

The mist was gathering upon the receding landscape and also upon the lingering eye, as those lovely mountains in long procession bowed themselves forever out of sight. Privations, evictions and religious persecutions were for the moment forgotten and the authors thereof almost received absolution, as the emigrants now sang together "Hen Wlad Fy Nhadau - The Land of My Fathers," the Welsh National Anthem - in Welsh.

The Red Dragon - the old flag of Wales - flying on the main mast beneath the British Emblem must have suggested to the casual observer a somewhat quixotic interpretation of the nature of the embarkation. The reader is curious to know the origin and meaning of this adventure. The origin lies in the seething discontent of Wales in the early half of the last century, when the people suffered greatly from industrial depression, educational disabilities and ecclesiastical persecutions. Agitation was set afoot to remedy this state of things, with the result that much improvement has come to pass. Wales is today in possession of a system of education second to none in Europe. The State Establishment of Anglican Episcopacy on a nation of nonconformists has been removed. The language of the people, long tabooed by a mistaken policy of the Government, has at last been given an honored place in the Schools and Colleges.

This agitation had a variety of forms; one form was a desire to emigrate into new unoccupied land where

Welsh people could settle together and preserve their language, institutions, and enjoy civil and religious liberty to the fullest extent. This form of the agitation was not confined to Wales; it found an echo in far off colonies where a strong community of Welsh people was found, notably in Australia and the United States.

Moreover it was not merely a political movement; it had also an emphatic religious character. Its intrepid and ingenuous protagonist, Professor Michael D. Jones, Principal of Bala Cong. College. The rev. professor had been on a tour through the Welsh Districts of the United States. He had been very much impressed and grieved by the marked degeneracy of small groups of his fellow-countrymen, dumped down in the midst of foreigners, many of them immigrants from the most backward and illiterate nations of Europe. These groups would have had another history had their lot been cast among their own countrymen, speaking their own tongue, having the same social customs and institutions, and especially the same religious beliefs and modes of worship.

Yet another aspect of the agitation was the strange lure of a free homestead. How this appealed in those days of small wage and scant leisure, to the toilers in mill, factory and mines! A Committee of Direction was formed in Liverpool and negotiations were carried on with various countries with a view of securing a large tract of land on favorable terms and conditions into which the Welsh could emigrate together. Having decided on Patagonia, the Argentine Representative in London encouraged the project after consulting his Government and getting their views.

The enterprise was much discussed in the Press, on platforms in Wales and in the United States. A persistent opposition was ably conducted in the Press, nevertheless a strong feeling in favor of the project grew more and more intense. Here is a typical instance of the enthusiastic reception in the Country: After a rousing speech advocating the settlement of Patagonia a Meeting in Cardiganshire, many stood up, at the request of the Speaker, to show their desire to emigrate. Among them was an old lady who expressed her desire in rhyme, which in English reads:

> *Though I have never seen a Ship,*
> *And though my years are quite four score,*
> *If God permit, I'll join this trip,*
> *For Patagonia's distant shore!*

In 1862 a Deputation consisting of Sir T. Love Jones-Parry of Madryn Castle, afterwards M.P. for the county of Merioneth, and Mr. Lewis Jones, an active Member of the Committee of Directors, were sent to confer with the Argentine Government. Here it was decided to found a Welsh Settlement in the Valley of the River Chubut, which runs East through the heart of Patagonia, from the Andes to the Atlantic. Preliminaries having been settled, the Argentine Government conveyed the Deputation by Steamer to the frontier Settlement on The Rio Negro. This was on the Northern boundary of Patagonia. The intention was to go from this point by land on horseback all the way to Chubut. The Government had given orders to the Governor to supply them with all necessary horses, food, guides, escort etc. Here, however, they learned that the project of reaching Chubut by land was impossible at that season, being midsummer, as there was no water on this route of 300 miles.

Sir Love Jones-Parry had no option but to charter an unseaworthy schooner. He shipped an American Captain, and some goal-birds for crew. The voyage was a short one but full of peril. They very soon had to put the Captain in irons, he having got mad and violent on account of excessive drinking. Afterwards the crew plotted against the lives of the two passengers. But adverse winds and fierce gales with tremendous seas intervening pressed all hands into a terrible struggle, long and fearful, to help the rickety vessel to weather the storm. They managed to keep the ship afloat and to steer aright, arriving in Chubut ten days after leaving Rio Negro.

The Deputation on their return to Liverpool gave a favorable report of what they had seen. The Committee lost no time in getting Ship and Emigrants ready to go possess the Valley of Chubut. We have now seen the "Mimosa" actually under sail and carrying on board the first batch of Welsh emigrants destined for Patagonia.

The genii were a trifle malignant along the coast of Wales, and very rudely shook the vessel in the neighborhood of Holyhead. Otherwise the voyage was uneventful enough. A respite was taken at Madeira, where the amphibious divers provided a delightful break of a monotony that was beginning to be felt. The pantomimic proceedings on crossing the line, the excitement of seeing the Fish flying, and the huge whales sporting like lambs about the Ship afforded further relief, till it was time to settle down to dream dreams and see visions of the destination that was now steadily drawing nigh.

One morning when they came on deck they found themselves calmly sailing up a landlocked bay. In the

dead of night they had reached their destination - they were sailing in the magnificent Bahia Nueva, Patagonia. There was much excitement when it was realised that their long cradling on the mighty deep had come to an end. They stood on deck viewing the land, spellbound. It stretched interminably in front of them end on either hand, undulating like the waves of the ocean suddenly arrested at the crest and rendered motionless.

It was not like the dear land of Wales, but brown and barren with sparse, tufted, coarse grass and stunted bush extending in every direction. The cliffs on either side of the Bay were whitish under thin dark caps of struggling growth in the grip of midwinter. The immigrants stood mute before a landscape of mystery. Expressions of disappointment essayed the landscape. But the spell of the land was too strong, and mere sight of terra firma before them was loveliness itself. With Gonzales they felt:

> *"Now would I give a thousand furlongs of sea, for an acre of barren ground, long-heath, brown furze, anything."*

On this day - July 28th,1865 - the anchor was dropped at Port Madryn in New Bay. As the first boatload drew nigh to the shore - a lovely sandy beach - an occupant suddenly sprang to his feet saying - "I vowed to be the first to plant foot on shore, and here goes". Immediately plunging into the tide he swam for the shore with the ease and the grace of a seal. He was the first to land. The anniversary of this memorable day has been observed throughout the ensuing years, as the chief holiday of the Colony, marked with various celebrations of joy and known as Gwyl y Glaniad - The Festival of Landing. It is difficult today to adequately appreciate the magnificent daring and spirit of the men, both on the Committee of Directors as well as those forming the company of emigrants on board the "Mimosa".

Imagine Patagonia sixty years ago [in 1820]. Very little was known about it and that little was all defamatory. Discovered exactly 400 years ago its very name was given it through a wrong inference from the print of a

foot roughly shod in rawhide. Magellan and his men landed in Patagonia in 1520 only to traduce the natives as giants with cannibal proclivities. Sir Francis Drake is more accurate when he regards their average stature as not greater than what may be found in Britain. More serious than the remarks of those earliest discoveries are the more recent observations of the great Darwin who, in the H.M.S. Beagle, visited the Patagonian coast and explored some miles inland here and there, in the first half of last century. He writes it down as an inhospitable climate, rigorous and storm-swept, barren and sterile, the world's greatest shingle bed. Humboldt also, puts it down as the Arabia of South America. The last two painstaking, and usually accurate observers, no doubt did more than all others to shunt Patagonia out of the thoughts of the civilised world, at the critical period when the streams of emigration were at their greatest volume, pouring the surplus populations of the old world into the progressive States and Colonies of the New World. Moreover during the long period of Spanish occupation and in the early years of the Argentine Republic, several attempts had been made to colonise Patagonia at different points, but every attempt ended in disaster. Famine or Indian attacks swept away every set settlement. Vestiges of these early attempts have been found at various points.

Much of this was known to the adverse critics of the Welsh Emigration Committee, and they made formidable use of it to paralyse the undertaking. With superb daring 55 years ago, this small company of emigrants exiled themselves to build new homes in the heart of Patagonia. Will the Sphinx of the Peninsula slay these also? Or will they save themselves by successfully solving the riddle of colonization?

Two representatives of the Committee had been dispatched some months in advance of the emigrants, to make all possible arrangements for the landing and the sheltering of the Settlers in New Bay. The Argentine Government generously helped these representatives. They were conveyed by Steamer to the southernmost settlement of the Republic, that on the Rio Negro. Here large purchases were made of horses, cattle and sheep, together with materials for building huts, implements for agriculture, food, seed etc. Peones (labourers) and gauchos were hired to care for the animals, and help to set up shelters for the immigrants. These representatives were Colonists in advance, one Mr. Lewis Jones, had been this way before with Sir Love Jones-Parry; the other was a Welsh-American from Missouri named Mr. Edwin Roberts. These two men chartered a small schooner to take these subsidies of the Government to a magnificent anchorage in New Bay. This was henceforth to be called Port Madryn after Madryn Castle in North Wales, the seat of Sir Love Jones-Parry, who was one of the Deputation sent out to investigate and report to the Committee three years ago. The necessary preparations at Port Madryn constituted a task of exceptional difficulty considering the absence of wharves and the varied nature of the cargoes. Worse than all was the real unhelpfulness of the peones and gauchos who scorned all work, except shepherding the animals on horseback, and swinging the lasso and bolas. Doubtless among them were some unhung scoundrels such as make the camps and frontier settlements, the danger zones of the fertile lands of South America.

A serious tragedy was narrowly averted on this occasion. One of the Agents went to and fro on the Schooner to bring the purchases from Rio Negro, the

other superintended the work at Port Madryn. Having failed to discover fresh water, Edwin Roberts decided to sink a well. Water was thus obtained, and though somewhat brackish, both man and beast welcomed it. Roberts went down the well to try whether the water would improve in taste by sinking deeper. While down in the well the peones stopped work and quitted the spot leaving the Agent at the bottom and without any means of getting up. The well was several yards deep, though the water was shallow. His condition was pitiable and hopeless while the peones remained in their strange mood. Shouting was useless, there was none to hear, save the labourers. Among them, however, was a negro whose humanity was stirred and at dead of night when all were asleep, he went and got the agent out of his perilous position. He also divulged that a plot had been formed by the peons and gauchos to murder him, and escape, taking all the animals and food with them far into the interior where the Government would be powerless to seize or trouble them.

The "Mimosa" was much overdue and the Schooner had gone on her second trip to Rio Negro. It was just such a plot as one might imagine a gang of scoundrels would concoct. Such a number of animals was wealth to them, and pursuit would be impossible. It was an opportunity of blunder not to be missed. It was strange that the possibility of such a plot had not occurred to the agents. Roberts and the kindly negro were well armed and kept on constant watch till a few days after, when the Schooner arrived and then the "Mimosa", thus removing the possibility of a dire catastrophe. A tremendous ovation was given by the Immigrants to the two intrepid pioneers Jones and Roberts as they stepped on board the "Mimosa".

The first impression of the land was that of unrelieved sterility. No river, no stream, not a drop of fresh water anywhere to be found.

"Here are many cows, why not milk them?" A farmer's wife, who had been accustomed to manage cows for many years in her native County of Cardigan, volunteered to make a try. She approached the cow in orthodox dairymaid style with pail in hand. Following quietly after the herd and making for those with youngest calves, she sang softly and persuasively the Dairymaid's coaxing strains "Dere di morwyn fawr I dere di & c." At last the cows got ashamed of beating a retreat and turning round, faced the strange pursuer. Mrs. Davies took the strange attitude for capitulation, and boldly yet cautiously, marched towards her selected victim, still warbling her lay. The cow, observing this, lowered her horns and charged. The Milkmaid flung the pail on the horns and flew towards the spectators, for every soul had come to watch the first milking, which proved a serio-comedy that nearly became a tragedy.

Poor Mrs. Davies was terrified and kept ejaculating, "They are demons, not cows. They are possessed with a legion of devils." The cows should not be maligned. Never before had they seen a woman much less seeing one daring to approach them. Possibly never did any man approach them except on horseback, or after first rendering them helpless with lasso or bolas.

The peones and gauchos were much amused at the attempt. They remarked that they had seen cows milked, but the cows were first lassoed and then tied to a post fixed in the earth. Sometimes the hind legs were also tied together. The Colonists had this lesson to learn before they could get milk from cows brought up wild

as these had been. One wonders whether when ruminating in the stillness of the night these cows felt a bit ashamed of the cowardly attack that had been made on a woman. Anyhow it seems strange that the very next day they tried to amend matters by attacking a man. A Settler was passing rather too near to the herd, when a cow made for him and knocked him down. She set to butting him savagely. The Settler however, managed to get hold of both horns, and was thus able to kick at the animal's nose and mouth furiously with his hobnailed boots. She was pretty soon glad to be allowed to beat as ignominious a retreat as the woman did the day before. Thus the balance was restored, arid man's overlordship fully vindicated. The failure to get milk was a keen disappointment. But the Settlers would soon get used to disappointments.

Edwin Roberts had managed to erect a line of huts on the land near the shore. The "pampero" - a dust storm - paid them a visit, and in a few hours there was not a hut left standing. A bit of favorable ground had been ploughed and fenced in with a stout thorn hedge and the same pampero blew the hedges away strewing them far and wide over the camp.

Accidents will happen, but if they don't end tragically, we recover and profit by the experience gained. Unfortunately, the landing was not to escape from the tragic aspect. A Settler named David Williams from near Aberystwyth walked almost straight from the boat to a neighboring hilltop and disappeared. Parties soon went searching about for him and fires were lit, and guns fired but without success, and not a trace of the man could be found. Many years after, some Indians visiting the Colony brought with them bits of paper and the remains of a pocket-book which were identified as

belonging to David Williams. The Indians described the spot where they had found them, mentioning that there were a few bones left.

Friends went to the spot and found bones and bits of clothing and reverently brought them to be buried in the Trerawson Cemetery. Thus after the lapse of many years, the mysterious disappearance was explained. Many strange surmises were suggested to account for the disappearance. The real solution was now clear.
The poor fellow in a fit of enthusiasm made up his mind to walk on to the valley. He succeeded in reaching a point where he had a full view of it. Possibly he had been to the river and had commenced his return journey when exhaustion brought on the end. There was no decipherable entry left.

It soon became evident that no settlement was possible anywhere near Port Madryn. It could only serve at present as a jumping of ground. The Valley of the Chubut must be the destination, and the sooner the Immigrants could be got there the better, so that the land might be put under cultivation and crops ensured for the Autumn. Industrial Wales was well represented in these Immigrants. Among them were farmers, miners, quarrymen, a smith, carpenters, joiners, masons, brickmakers, a grocer, a draper, a shoemaker, a tailor, a printer, a shepherd, a chemist, a doctor and three nonconformist ministers. The ambition of everyone was to become a possessor of a bit of land for his very own, whereon he could work and live and bring up his family in peace and plenty.

Chapter 2

The Sphinx* Encountered

Arrangements were hurried forward to get the Settlers, animals and goods into the valley of Chubut. The problem of removal was a difficult one to people unaccustomed to pathless and waterless regions.

It was decided that the younger men, married and unmarried, would cross overland in parties, a distance of forty-five miles over a dry and barren desert. The women, children and older men would be sent by the little Schooner to the river mouth. The lifeboat of the "Mimosa", which was to be left for the settlement's use, would be taken to the river, laden with food, and would start on its voyage as the first party commenced their journey overland. Food would thus be waiting for the travelers by the time of their arrival in the valley. These arrangements were excellent, but "The best laid schemes o'mice an' men gang aft agley."

Nineteen youthful men were selected to form the first company to make the journey. The start was to be made early in the morning and there was to be a bit of ceremony over it. The Captain of the "Mimosa" instructed them in regard to the importance of not missing the right direction. He pointed out the straight line to the south, which they were very seriously urged to maintain with as little deviation as possible. "Keep to the south, boys, whatever you do, mind to keep due south." The most solemn warnings are the least heeded generally. Bitterly did this party regret their departure from a warning of such gravity.

* Sphinx, Thebes Egypt. Greek mythology: A winged monster with lion's body and human head/face who strangled those who were unable to solve its riddle.

The gun fired the signal to start. They were all ready and started together. A Packhorse was allotted to accompany each party, to carry food and water for the journey. Every man also had to carry, in addition to his bedding and rifle, one agricultural implement - a spade, shovel or axe. One poor fellow insisted on trundling a wheel-barrow which he had brought from his home in Wales. His attachment to the barrow caused much amusement. He however stuck to it for a couple of miles or so, and then with a sad countenance left his dear idol on the track side.

LANDSAT image of the Lower Chubut Valley
(courtesy of NASA)

At length night came and everybody was glad of the promise of rest after a weary, monotonous tramp. A light supper satisfied all. Then, after the novel experience of bed making on the camp, everyone tumbled into bed. This first camping out on the open pampa was a weird experience, to lie defenseless and asleep, in peril from savage beast or still more savage man. It is not granted to everyone who has to improvise his hard pillow on the wind swept plain, to have a vision of an open heaven and a band of angelic ministrants, to encourage one and glorify his venture. Instead of a vision, our band was suddenly wakened by a strange

yelping and barking. In an instant they were on their feet. It must be some dog betraying the proximity of Indians. They got ready to defend themselves and stood on the watch all night. Daylight revealed nothing more serious than a prairie fox.

On the second day's journey a much more serious sign of danger filled them with fear. Ahead in the distance was something appearing to them like the smoke of an extensive fire. Even the guide - Edwin Roberts a Missouri man - was in fear. His interpretation of the phenomenon was that the Indians were setting the prairie on fire in front of them with a view to enveloping them in flames. He ordered a change of course. "We will march due East to the Sea, and thence due South for the River". The alarming spectacle was no other than a pampero, one of those sudden dust-storms which frequently visit the dry camps of Patagonia.

This most unfortunate deflection doubled the length of their journey and well nigh brought about the destruction of the party.

Reaching within sight of the seashore about ten that night, without a drop of water left; they lay down supper less and almost dead with fatigue, they slept. That night they dreamed dreams of bubbling springs and abundance of water, of which they drank liberally. But to drink in a dream is only to dream of drinking. They rested awhile by the sea and were somewhat refreshed at the sight of it. It was the sight of an old friend that never treated them so badly as this dry land was treating them. They remembered that on that long voyage of 7,000 miles, they never suffered as they now

did. A few drank of its playful water and suffered thereby.

Again they marched south. A skunk presently drew their attention hopping and jumping before them. The beauty of the tiny creature was much admired. But what was it? Nobody knew. Possibly it was a dangerous animal. Most poisonous animals and reptiles are also beautiful. They were in no mood to run risks, and so they ran the little thing through with the bayonet. They got their reward and for many a day they needed no hound to track them, and they were undesirable companions. The fetid secretion squirted over them got into their eyes resulting in vigorous antics and dancing.

The skunk interlude roused the spirits of the company for a little while. The gloom of the situation soon returned and at nightfall raging thirst almost made farther traveling impossible. During the day the company was breaking up into small bands. The more vigorous going ahead, and the weaker ones lagging behind. A small party even showed signs of incipient madness by starting to return to Port Madryn. Others coming on persuaded them to give up so impossible a task. They decided to go no farther that night and looked around for suitable camping ground. On the verge of despair, they began throwing themselves on the ground, when someone thought he heard a call far to the South. All listened intently. Yes, it was a call. Presently "It is Edwin's voice." The call becomes more distinct and was drawing nearer. "Water," "water" "water" boys, and enough." A voice of hope in the valley of the shadow of death. Edwin was soon in sight riding on the horse and in his hand a large can full of water. The hearts of all were revived.

The rider dismounted and himself poured a tin cup full for every one. One of the party, recalling the incident, said of all the water I have ever tasted it was the sweetest. One cup put a new spirit into us". "It is from a large lake a little farther on. Keep straight on till you see a fire, there we shall camp", spoke Edwin, the Missouri man, and the guide of the company. He has made amends for his deviation from the straight track through fear of Indians. Forging ahead with two or three of the strongest he came first by water, and had quickly retraced his steps to supply the reviving draught to those who had failed on the way.

Dragging themselves along, they reached the fire signal by four o'clock in the morning. There was a boiler full of hot coffee in readiness and some hard biscuits. It was the best relished meal ever eaten by them they said. Having all come safely together once more, and enjoyed a refreshing meal they lay down and slept far into the afternoon. When they awoke they had a good wash. Then the boiler was set on the fire again. Another meal of tea and biscuits was next enjoyed. On the margin of the lake they remained in order to visit the river mouth to see if the boat had come from the Bay. Finding no sign of the boat they went up along the bank of the river, when to their dismay they saw what seemed to be an Indian encampment a short distance up stream.

Startled in this manner all got ready to repel an attack. Moving warily towards what looked like a fortification, they drew nearer, and finding no signs of life, they entered into a well-planned Fort built on the riverbank. It had a moat on three sides, the river forming the fourth. There were a few huts, some of adobe and some of burnt brick. The earth from the moat had bean

thrown inwards. It was a mysterious discovery. On inspection it was clear that it had not been in use for a long time.

After the departure of the first company from Madryn, two stalwart mountaineers who had watched over their flocks in the valleys and glens of the Arenig & Cader Idris, were given a flock of sheep to be taken to the valley. With no road, not even an Indian trail, only one vast undulating dry expanse of shrub, scrub, thorn and tufted grass before them, they bravely undertook the charge, carrying a bottle of water each and a few biscuits in a wallet. All went well on the first day, and after a frugal meal, they lay down and slept. They woke up early in the morning to find that the sheep had forestalled them and had already strayed out of sight. They went in search of them, wandering about in every direction. When night came on both, the shepherds had aggravated the loss by losing one another. Griffith in vain shouted for John. He lighted a bonfire, but there was no answering flare.

It was an awkward predicament for John, who had the wallet of biscuits. Weary and anxious Griffith Hughes slept that night without food, flock or friend. Saturday found him up early and he was fortunate enough to find the flock. But not finding his friend he was still without ford or drink. On Sunday he kept following sheep and decided to kill one on the morrow to supply him with food.

When Monday dawned he found the sheep had strayed again and were nowhere to be seen. Exhausted and suffering from a raging thirst the sheep interested Griffith no more. He selected his direction and doggedly followed it as best he could. His mind began

to wander. He seemed to see water and to hear the sound of water all round him, while in reality there was nothing of the kind near. After pursuing his course in a dazed condition for some hours, Griffith saw the broad Atlantic in front of him. The sight quickened his pace. Walking into the tide nearly up to his armpits, he drank eagerly of its bitter water. He felt loath to walk taut of the Sea; it was so refreshing to stand in the midst of the caressing wavelet. Retracing his steps till he found the beach high and dry, he dropped himself into the coaxing arms of Morpheus.

In the dead of night Griffith woke up considerably refreshed, and the calm night being lit by the moon he ventured to make for the River at which he arrived with the dawn. Dipping his empty bottle in the River he drank, and drank only too liberally of its delicious beverage. He then lay down on its bank and slept. Out of this sleep he was ere long awakened with great internal pains. Warming a bottleful of water in the ashes of the dying embers, he drank it as an emetic. The expedient proved effective in producing violent sickness, which undoubtedly saved his life. Shortly after, having got much better he found that the first batch from Madryn were in camp a little higher up the River. Arriving in their midst he found that they, like himself, were dying of hunger as the party in charge of the food had not yet arrived, nor had the Boat. "What have you boiling in the pot?" asked he. "Fox" was the reply. Unhappy Reynard had come by his death at their hands. Griffith received, as a great favor, a small portion of it together with a morsel of biscuit. Here and thus Griffith Hughes broke the fast of nearly five days, endured, with heroic fortitude. News came later that John, his lost partner, had returned safely to Madryn.

A score of immigrants had now arrived at their destination and were camping on the margin of the River Chubut. The dread of thirst haunted them no longer, but in its stead had come the dread of starvation. Wild-fowl furnished a few meals. Ammunition, however, was precious and getting exhausted. They must economise this means of defense. The food problem became serious as the lifeboat arranged to start, laden with provisions, on the same day as they left Port Madryn, had not arrived. While in this sore strait, a remarkable visitor stole unannounced into their midst. It was a fine big dog, which came frisking and jumping about into their camp. Suddenly alarmed by this indication of the proximity of Indians, everyone instantly put himself in readiness for defense. After a long spell of watching and waiting and nothing turning up, the anxiety became less tense and the dog got a little attention. He made himself quite at home, as if he had always been with them. He was named Antur Venture. He gamboled and played about and heartily reciprocated their attentions. They greatly regretted that their cupboard, like poor Mrs. Hubbard's, was bare so that the poor dog could not have a bone.

The next morning the dog quietly left the camp, and some of the men as quietly followed him, to make observations. They had not gone far when they observed the dog attack and bring to the ground a big guanaco, which the men instantly fetched into camp. The reader can well imagine the joy in camp at this unexpected fall of manna in the wilderness. The dog further supplemented the gift by bringing into camp a few hares. This friend in need then disappeared the same day as suddenly as he came. Where had he come from? There was no dog belonging to any of the Settlers. How was it that he never turned up again? It

was considered at the time a mysterious interposition of Providence to deliver their lives from death. Fifty years after, an old Settler referred to the incident as a most merciful miracle.

Chapter 3

The Sphinx Grows Rampant

Successive parties continued to arrive at the River encampment from Port Madryn, which added to the gravity of the situation at the Chubut end. On leaving Madryn, each party brought only just enough food to last the journey. The non-arrival of the boat with provisions portended a disaster of the first magnitude, no less than the starvation of those who through terrible privations and sufferings had arrived safely, and were together in the Valley of Chubut. The outlook was so serious that a party of eleven decided to volunteer to undergo the risk and hardship of a return journey to port Madryn to report. This was a mad venture to undertake. They had absolutely no food for the journey. Taking nothing but water only for a 45 miles march, and all hungry men already - was it not sheer madness? But the situation was desperate and demanded a desperate remedy. Extremes meet, and madness sometimes becomes highest sanity. Having accomplished the greater portion of the journey, they became utterly too exhausted to proceed further, and so made a halt. Drawing together, they all knelt in prayer. The words were few - terribly earnest words. Prayer over, a big bird drew their attention flying slowly overhead. A shot brought it down. But this shot did more than bringing the bird down, for it brought an answering shot from no great distance. It came from a parallel line of travelers going in the opposite direction to Chubut Valley. They were at some little distance on one side, and this accounts for the parties not knowing anything of each other. There was no road and the bush was thick.

The Madryn party came to the help of the despairing eleven from Chubut, cheered them and supplied them with food sufficient to enable them to continue on their journey. The eleven did reach Madryn but more dead than alive and on the verge of collapse. On their arrival vigorous measures were adopted to cope with the situation at Chubut. A flock of sheep had arrived in the Valley, which supplied them with meat.

This, of course, the eleven did not know. This brave party of eleven were now informed that the Lifeboat containing provisions had been duly dispatched but had been driven ashore, and wrecked just outside the entrance of the Bay. Having considered the urgency of the report from Chubut, relief parties were immediately formed at Port Madryn to take packhorses over to Chubut.

The Schooner also was readied to be dispatched forthwith, with as many women, children and older men as it would conveniently carry together with provisions.

No sooner had the Schooner sailed out of New Bay than a great storm came; one which drove it a great distance out to sea, towards the fringe of the Antarctic. It was a solace to remember that there was no lack of food on board, thanks to the provisions destined for the men at Chubut.

When the packhorses arrived in the Valley they gave the news that the Schooner was on its way to the River-mouth with abundant provisions, and also with most of the women, children and older men. All the men were full of joy at the news and were looking forward to the delight of having their loved ones around them once more.

After a few days had passed, and no sign of the Ship was seen, the men began to feel anxious. As time wore on and still no sign of its coming, the suspense became intense, and fears were stealing into their breasts that some dire calamity, had possibly overtaken the frail vessel. They plied the men that had come with the news, with questions relative to the exact day of sailing. Two days were ample time for so short a voyage. Ten, twelve, fifteen, sixteen days passed and no sign, no news of it. They realised that though there was sufficient food on board, the water must have given out. This added poignancy to their sorrow, for did they not know what this experience was. The condition of this community of men was pitiable in the extreme. The worst fears for the safety of the ship were being entertained, and the camp became a scene of wailing and grief that was heartrending to witness. Each of them had a mother, wife, sister or child in that ship. Already the suffering endured, first on the marches from Port Madryn, and then from lack of food in the Chubut encampment, had tried the strongest constitution. Now this long deferred hope brought them well nigh to despair.

At first they were busy getting temporary dwellings put up to shelter their loved ones when they arrived. Thoughtfully and lovingly they made these as snug as possible by means of pampas grass and willows and adobe. Once a disastrous fire destroyed some of the coziest huts, burning with them many useful things and treasures, from the old homes, that could never be replaced.

Between the Camp and the mouth of the River a promontory in the pampa intercepted the view of the

Sea. A well-beaten path was made from their camp to this point, which they visited several times in the day. Here they would sit and, with misty eyes, search the Sea beyond the dreary strand of the estuary of the Chubut River.

Relief came at last. It was on the 17th day of the cruise that the little ship was seen making for the mouth of the River. Families were overcome with the joy when the lost members stepped the gaps of the circle, making it whole once again. Their plight was pitiful. In constant peril from storms, icebergs, and mountainous seas, their nerves were in a sad state. The preparation of food had been almost impossible, so that though there was abundant food on board, yet were they nearly being famished. As they trudged towards the encampment in groups, the men carrying the little ones, hugging and kissing them in a very delirium of joy, and the wives pale and weakly leaning on their arms, in a state of subdued rapture at their escape from the jaws of death, they presented a spectacle that will ever live in the memory of those who witnessed it.

Indifferent were the preparations for the reception of the voyagers, so slender was the hope of ever seeing them again. Had they arrived some days earlier they would have bean surprised at a novel exhibition of welcome. An unusual variety of bird and beast had been trapped or shot, for the feast of rejoicing at their homecoming. Geese, swans, ducks, flamingoes, partridges, guinea-fowls, pigeons, hares and guanacos, lay on a trellis work, placed there by the tender affection of relatives and friends to await the hour of their arrival. But there was still abundant game at hand, and they were at home to henceforth enjoy it - in their new home.

Fairly decent cottages had been prepared. The old brick houses found in the fortress had been repaired and others of adobe had been run up. Under the circumstances, however, the men felt grieved that they could not lead their dear ones to better house and table, after their exceptional experiences on the stormy main. To the women and children, after the hardship of the ship, the encampment and the valley around were very paradise. The calm river, winding so leisurely in the neighborhood, as if hesitating to venture out into the sea, its silent murmur was soothing. The willows, pampas grass, and bulrush fringing its margins, the meadow-like stretches of quiet green in the bends of the river, where twittering birds and cooing pigeons flitted about, presented a contrast so cheery that it was bracing to the shattered nerves. The men elated with the recovery of their lost ones would apologize for the humble homes they had been able to provide, but the women would complacently smile and say "Hush, they are mansions of the blest - are they not?"

After the departure of the schooner, the remaining immigrants were arranged to leave in successive groups for Chubut. Each group had charge of a certain number of livestock, and were to allow an interval of a few days between each group.

A number of the women folk had refused to go by the ship, insisting on being allowed to walk it over by land. Two of these were advanced in years with hair quite grey, but they were strong and capable. The others were young women. The husbands accompanied the married women, together with some boys in their early teens. The pigs, three in number, comprised the portion of livestock entrusted in their charge. The elderly

women, accustomed to farm life, had these pigs under their care since their importation and had got them quite tame. The pigs followed faithfully, giving no trouble along the route. When the company rested the pigs would be busy turning up the ground and getting various roots to supplement their rations. The party were alarmed to discover that their allowance of water had been used up much too soon for the distance accomplished. Soon however, they came over a cask of water which had been left in readiness for the road makers.

The road construction was given up long before this point was reached, and the cask of water was a fortunate find in this emergency. Ordinarily it would be regarded as quite undrinkable. It was not the time to be overly particular. It was however heavily skimmed and the "cream" given to the pigs. Then boiling it and pinching the nostrils somewhat, they managed to satisfy their thirst, and preserve a little for the next stop. When night came they made their beds as comfortable as they could, and retired early. The women chiefly spent the night listening to the extraordinarily vigorous snoring of the pigs, and wondering whether it would awake the curiosity of savage night prowlers and attract them to the encampment. Morning came after a night quite undisturbed, except by the snoring.

The next day they were afoot early and pacing joyfully and hoping to reach the Valley before nightfall. They were this day in for another lucky find. This time it was an ostrich's nest, with 21 fresh eggs, looking like a heap of beautiful green basins piled together. It was the first discovery of the kind since landing. They stood over it in amazement at the exquisite green color of the

eggs. They ware distributed among the party and formed a welcome addition to their larder.

The friends in the Valley were aware of the women's intention to arrive about this time and formed a party to go and meet them carrying a supply of water with them. This was a happy thought for they met them quite exhausted and badly in need of water, some distance from the Valley. The women had a more favorable time during this journey than had befallen to some of the other groups.

The schooner after discharging its cargo returned to Port Madryn for the remaining goods. This transfer from the Bay proved a difficult and tedious business. Drought oxen and two heavy wagons had been brought from Rio Negro, but the Settlers were not accustomed to manage oxen in plough or wagon, so this provision could not be turned to any account. Attempts to utilise them proved dangerous fiascos, and the wagons were never removed from the Bay.

The management of both riding and draught horses is very different in South America to the way they are managed in Great Britain. At the time of the landing of the Welsh, there were practically no draught horses in Argentina for agricultural purposes. The native method was to tighten the raw-hide girth of the horse as taut as man's utmost strength can pull it. Then, one end of the lasso is secured to a ring in the girth and the other to the object. The man then mounts the horse, whips and spurs it till it drags the object along. The Settlers could not adopt this slow and cruel method, and had to train horses to pull by the collar. This required time and young horses. Agricultural work in Argentina was carried on mainly by draught oxen.

The second voyage of the Schooner was done in normal time. Having returned to the river the men were called to unload the cargo. This was early in the morning before they broke their fast, and they continued working all day without food. At sunset the Settlers opened a bag of rice and took a quantity for a meal. On seeing this, an Officer of the Ship came on and began abusing the men for opening a bag of the cargo. The men resented his impudence and one of them with clenched fists approached the Officer and charged him with the inhuman treatment of allowing them to work, all day without a morsel of food. He also warned him that unless he ceased his insolence, he would deal him a blow he would not soon forget. The Officer, a coward and a knave, betook himself quickly back to the ship.

By means of a small boat the Settlers got all the cargo safely stored within the encampment three miles up the river. The closing efforts were not to pass without a mishap, for one of the men - John Davies - in pushing the boat from the bank fell into the River. Although an expert swimmer, he never came to the surface again. The River like all the rivers on the East coast, is heavily charged with minute alluvial, which makes it impossible to see anything beneath the surface. Many lives, especially of children, have been irrecoverably lost owing to this peculiarity of the River. The sad accident brought a dark cloud over the little Colony. It was all the more sad as all the immigrants, with all the goods and chattels, were now together again having safely come by Sea and Land from Port Madryn to the valley of Chubut. It was a delightful reunion of families and friends, after vexatious and anxious separations, on the margin of Chubut where now there was food, water, shelter and rest for all.

The Chubut River

Sunday was now at hand and it was to be a memorable day. The first day of real rest since the dispersion at the time of landing. It recalled to mind the Liverpool experience when they found themselves, brought together from all parts of Wales, and were not a little perplexed at the variations in garb and idiom so forcibly revealed.

After much suffering and many perils, both on Sea and Land, the same people that had looked each other in the face on the banks of the Mersey, found themselves together on the banks of the Chubut in Patagonia, some 7000 miles distant from the old home.

This first Sunday must be a Thanksgiving Day for the Deliverance and Guidance afforded throughout their pilgrimage. The large storeroom was improvised for a Sanctuary in which the sacks of rice and wheat were arranged in rows and tiers to serve as seats. The men, women and children donned their Sunday garments and with glad step, a sunny countenance, and hymnbook in

hand, they wended their way and entered into His courts with praise.

Rev. Abraham Mathews conducted this first Sunday morning Service. He chose for the subject of his discourse "The experience of the Children of Israel in the Wilderness". It was an earnest and inspiring Sermon. The prayers were also impressive, for the spirit of gratitude manifested. The singing was particularly notable. The precentor, Aaron Jenkins, with a powerful tenor voice, led the singing. The last hymn sung that morning was, and still is, a great favorite in Wales. On that occasion every voice joined in singing, as only a Welsh congregation can, that grand old hymn:
>"O fryniau Caersalem ceir gweled,
>Holl daith yr anialwch i gyd."

>["From Salem's heights we shall review,
>The desert marches all the way,
>And view the windings of the road,
>That led to joys of perfect day."]

It was a memorable service.

Chapter 4

The Mud Settlement

Reference has already been made to the unexpected find of an abandoned fortress where the first party that arrived from Port Madryn camped in the Chubut Valley. It was a disconcerting surprise to come upon evidence of pre-occupation, of which no one had any knowledge. It was evidently constructed by civilized people. It is a pity that the story of this structure could not be known. Was it a silent witness of an unrecorded tragedy? A little ship sunk in the river close by, lends color to such suggestion. Fitzroy, who visited this Valley during his survey of the eastern coast of Patagonia, remarks that the Valley of the Chupat River was teeming with wild cattle. Here rumor takes up the tale and tells us that a certain enterprising gentleman of the name of Jones - was he a Welshman too? - having read Fitzroy's remark determined to get up an expedition of hunters to go and fortify themselves in the Valley. The object was to kill the cattle for their skin and fat.

The Indians, however, somehow got wind of the enterprise and anticipated the expedition. They came down from the hinterland and literally swept the Valley of all the herds of cattle, whose number had so astonished Fitzroy, driving them West into the Valleys of the Cordillera. It was evident that the expedition was counting upon a lucrative adventure. Several small houses, or huts, had been built, some of them of burnt brick, together with an oven of burnt brick. All these erections were on the plot of ground some hundred yards square enclosed by a deep and wide moat, the

River forming one side. The earth excavated from the moat was all thrown on to the inner side of the fortress. Such a show of fortification of burnt brick was an unmistakable indication that the party meant business, and a stay of some considerable length. There must also have been a fair number of labourers. The moat alone entailed considerable labour, but it was deemed essential for defense as the Indians were reputed never to cross water to attack.

Rumor goes on to say that the members of the expedition, in their disappointment, quarreled among themselves, and for some reason sank their ship and went overland to Patagones, 200 miles away. This expedition took place in 1853, twelve years prior to the coming of the Welsh Settlers. This date being recent, it may well be that in the Rio Negro Colony there were some who knew all about the expedition and passed on the information. Certain it is that the Welsh Settlers now set to repairing the houses and huts for their families. There was material by way of willows, rush, and pampas grass growing at hand for the task of repairing, as well as for setting up new structures.

There was a large building, which was used for a storehouse, in which the various provisions could be housed in safety. The headquarters of the Colony were fixed in this fortress. The Settlers not wishing to scatter far apart just yet, resided within or just to the outside. Two grain mills driven by horse-power, and brought from Wales, were set to work within the fortress. Matters were getting normal and everyone recovering from the effects of the trying experiences of the last few weeks, when a party of Government Officials arrived by ship from Rio Negro to hoist up the flag of the Argentine Republic, and to grant to the immigrants the

formal Official permission to take possession of the land.

The town of Gaiman, on the north bank of the Chubut River, in 1906. W.C. Rhys was the first Municipal Secretary for the Colony here. (Photo Bowman)

The Deputation, at the head of which was Colonel Julian Murga, the governor of the neighboring Colony of Rio Negro, was an imposing affair. A considerable retinue composed of a strong escort of soldiers, secretaries, surveyors, and servants accompanied the Deputation. The ease and speed with which they traversed the intervening stretch of camp from Port Madryn was a startling contrast to the almost tragic journeys of the Settlers along the same route.

The party consisted of natives accustomed to long journeys over dry, barren and pathless tracts. They were also mounted on horses used to the pampas. Above all these advantages, a very heavy fall of rain, for some days before the arrival of their ship, was a most opportune piece of good fortune. The camp on

that account was a cool and refreshing tract, with pools of fresh water here and there to satiate the thirst of man and beast.

The flag of Argentine was hoisted on September 15th 1865. The ceremony was brief and interesting accompanied with the usual hurrahs, vivas and rifle volleys, a lingua franca which the Settlers understood and joined in heartily. The capital was named Pueblo Rawson after the Minister of the Interior who had conducted the negotiations with the representatives of the Liverpool Committee. With due solemnity, and all pomp possible under such circumstances, an official document was drawn up and signed, sealed and witnessed recording the transaction as done on the north bank of the River Chubut, latitude 43.21.S. and longitude 65. 2' 50'' W.

Three copies of this important document were made, one for the National Government in Buenos Aires; another intended for the national archives in Rawson and to be left in the custody of Colonel Murga; the third copy was delivered to the leader of the settlement, Mr. Lewis Jones. After a brief rest of a few days the official deputation returned to Port Madryn along the same route that they came. The horses they had brought with them by ship from the Rio Negro Colony, and they were taken back in the same manner.

The Deputation, inadvertently, in another way conferred a great boon - they gave the Settlers a straight road to Chubut. During their short stay in Port Madryn the immigrants had cleared a wide and straight road for about 3 miles. Beyond that point the companies traveling from Madryn to Chubut did not follow in each other's track, and on this account no well marked path

had been made. The Deputation riding in strong cavalcade in regular, military formation, to and fro over ground soaked with the unusual downpour of rain, left behind them a fairly clear and direct road which became the permanent main road between the Chubut Valley and Port Madryn.

The Settlers having now gained opportunity for leisure began to take a view of their surroundings. The Valley was about 3 miles, more or less, in width. The encampment was some 4 miles up the River from the sea. The valley continued westward for some fifty miles. The River was winding leisurely, a veritable serpent, channeling the middle of the valley into an innumerable series of diminutive peninsulas. These were luxuriantly ornamented with pampas grass whose graceful plumes were never still; with willow trees fringing the margin of the River and urging their supple boughs to meet across the stream, in its narrower widths; also with the bulrushes nodding to the faintest breeze, and abundant coarse grass with reeds and rushes in the hollows.

These small peninsulas were aggregated into a number of immense curves which occasionally almost touched the low hills which bounded the Valley on either side. About the centre of the Valley one of these curves actually washes the foot of the hills on the south side. And then another curve hurries diagonally to perform similar service to the hill opposite on the northern side. The divisions thus affected are often referred to be the Upper Valley and the Lower Valley.

North, south and west the pampas rose in successive tablelands stretching farther and farther into the

unknown and mysterious interior, where wild beasts and wild men had it all in their own way.

A vision of far distances was very impressive to people who had spent their past days in the narrow vales and glens amid the mountains of Wales. Such a vision of vastness and monotony combined, quite overwhelmed them.

The Settlers were not long in the fortress before they realised it was not the boon they had thought it to be to them. Like Jonah's gourd it gave a welcome promise of shelter and defense till they could erect more convenient and permanent abodes. But like the gourd also, it brought a grievous disappointment. The rain continued off and on for a long while. The fortress over which the clay soil from the moat had been flung became a grievous quagmire. They sank to their knees in the sticky mud. Imagine over a hundred men, women and children kneading a limited apace of some hundred yards square, going in and out of their huts and doing necessary work! Treadmill was not to be compared to it. It wrought havoc upon their tempers, characters and circumstances.

When the rain commenced they had 800 sheep under their charge. When the ground had sufficiently dried up so that they could go about, the sheep had strayed out of sight and were never seen again. This was a calamity indeed, for with the sheep went their hope of living till the harvest, which was months ahead. An inventory was taken of the provisions in stock and they were found insufficient to carry them over the intervening period.

The Agent of the Committee, who was also their elected leader, was interviewed as to what arrangements had been made for this contingency. He replied that the situation being quite unforeseen, especially the loss of the flock of sheep, no arrangement had been made to meet it.

The tempers, developed and embittered by the mud, were let loose upon the head of the leader, who had not been omniscient enough to forecast the accidents and provide for them.

The little ship was still in the mouth of the River. They elected a new leader who was to go to Buenos Aires and report their plight to the Government. In the same ship went also the rejected leader. Harassed and disgusted, he left them in the mud and muddle. Extremists among them were not satisfied with this appeal to the Argentine Government. They must petition the British Government to remove them to some spot under the Brittish Flag.

This was a most unwarranted conduct, and very discreditable to those implicated in the plot. The facts narrated in the petition were either incorrect or grossly exaggerated. Neither were all the signatures genuine.

The attitude of the Argentine Government had been so noble and generous throughout, that the conduct of these disaffected and implacable few, must be regarded as base ingratitude. They stood however, in no representative capacity, and their number was insignificant. There would be no need of referring to their petition. Were it not that it drew John Bull out of his way, to pay a visit to the Settlement and report to the British Government.

In 1865, the Colony issued its own money in one-pound notes

Chapter 5

A Modern Androcles and an Indian

The ex-leader realized the seriousness of the situation created by the high-handed procedure of the Settlers. He was the sole representative recognized by the Government in Buenos Aires, and the Committee in Liverpool. He related to me how, being sad and grieved at the unhappy turn of affairs, he decided one day to take a walk over the lovely pampa to port Madryn.

Towards the end of the walk and adventure happened to him, somewhat similar to that embalmed in the Ancient Story of Androcles and the lion. The story is worth recording as giving the first introduction of the Settler to the silent lion of South America.

Our entertaining goldsmith is quite at variance with facts in his description of the puma and his habits. He describes the puma - as the lion of South America is universally called - as a semi-innocent, cowardly quadruped, satisfied in the vicinity of human habitation with an occasional sheep, but having no ambition to exert himself in procuring anything more substantial. Dear old companion of our wondering boyhood, he would not have liked to have met a puma "by moonlight alone."

Hudson in "The Naturalist In La Plata" has an excellent description of the habits etc., of the puma, with some capital puma stories. But he is very lenient with the

brute. Perhaps the less enervating climate of the far South develops fiercer specimens than those met within the genial regions of La Plata. We know of several instances of men being attacked by it. Hunger, perhaps, prompted the attack; still, Patagoneros are not disposed to endorse the opinion of those who compliment the puma as an "amigo de cristianos". In Patagonia it is by no means an uncommon thing for the brute to attack full-grown heifers and colts.

A neighbor of mine had a big, strong, working horse called "Satan", on account of its vicious temper and incorrigible habit of kicking. One day "Satan" came to the house with two ugly gashes on his haunches, one on each side, evidently scored by a puma. But we felt sure the puma was scored also, and that he had blundered that morning in the choice of a victim. The lion is not always victor.

Our Androcles had to walk across a wide tract of camp - some forty five miles - on one of the table-lands of Patagonia. He started in the early morning, and his course lay through shrubs and stunted thorn-bushes on one monotonous, undulating stretch.

Occasionally herds of guanacos - a species of deer - were to be seen browsing on the sparse tufted grass that grows among the bushes. On the highest bit of ground near, stood the sentinel buck. He had long been watching with keen eye.

A guanaco (lama guancoe) stands alert. Guanacoe hunting kept meat on the first colonizer's tables.

As Androcles gets nearer, he hears the sharp, shrill neigh of the buck, very similar to that of the horse. A sudden cloud of dust informs him that general stampede has followed that neighing. Sometimes he spies a flock of rheas, the three-toed ostriches of South America, tugging at the smooth pods of the algarrobo (carob-tree), or digging up the wild potato and swallowing it root foremost, thus closing together into a harmless bundle the formidable spike-like and spreading thorns of that succulent tuber. These also will prefer keeping him at a respectable distance. Viewing their plight, one thinks that, much more than the camels do, they deserve the appellation "Ships of the Desert". How they spread out, now one wing then the other, as the mariner sets his sails to catch the breeze and thus accelerate their already swift progression.

A chick of the Patagonian ostrich (Rhea Darwinii). Very abundant in the time of the Colonization. Not now! (Photo Roger Rhys)

Smaller game such as hares, armadillos, guinea-fowls, and an occasional fox, pole-cat, lynx, and skunk are startled. The dread of man is great among wild animals. Are they instinctively apprised of the innate blood-thirstiness and implacable ferocity of the human biped? An occasional glimpse of these dwellers of the extensive solitudes of the pampas relieves the journey of much of its dull and irksome monotony. The Traveler is also somewhat elated to find himself a spectacle at which the universe shies. He will get smaller by and by.

He has now been walking for many an hour, and is getting exhausted. There is not a river, lake, spring or pool - not a drop of water to be met with on the whole journey. He has long since finished the bottleful he had brought with him, and his lips are parched. The pathless portion of the wilderness has been crossed, and he has now reached the crest of Bryniau Penfford, where the road commenced from Port Madryn ends. Those who made this bit of road thought they had carried it far enough "for nothing". Our friend has still some three miles to walk, but the road is downhill, and at the end is a well!

Patagonian hare or mara
(Dolichotis Magallanica)
(Photo Roger Rhys)

Crested tinmamou (Eudromia alegans), called generally partridge in Chubut. They were abundant up to the end of the thirties. Roasted they were a treasured dish.

Armadillo

The gray Patagonian fox (Ducicion culpaeus), roams the Patagonian wilderness still.

Have you known, reader, what it is to endure the distressing pangs of thirst, and then to realize that the delight that comes with the discovery that relief is only three miles away! Having proceeded a little along this road, our Androcles, looking back over his shoulder, sees, to his dismay, a puma following at some distance. He stops, and the puma stops. He starts again and the puma starts. He quickens his pace and the brute quickens his. "He means to have me", reflects the Traveler, as soon as it is dark. If I could only reach the well I might be able to save myself".

Puma (Felis concolor) also called cougar and mountain lion

The Artist of the Occident is already busy with brush and palette, touching into glowing hues the Patagonian sunset. Inquisitive clouds draw near to watch; they crowd upon him; he shakes his brush at them, and they writhe in molten gold. He finishes and the whole illimitable canvas of the western horizon is one vast blaze of gorgeous colors - inimitable, indescribable... As he sinks, he flings back along his path a farewell

kiss, which the east receives, blushing as her hero sinks to rest.

Androcles was in no mood for poetry; he wished he had a rifle or revolver. It was getting darker and darker, for twilight is of short duration in eastern Patagonia. The puma was making the intervening distance less and less as night crept on. At last the well was reached. There stood the bucket, with rope attached, beside the trough, and the board lay stretched across the wide mouth of the well. Snatching up the bucket, our weary friend stepped on the board. The puma had stopped, and was calmly watching the proceedings and waiting the development of events. The Traveler dropped down the bucket and drew up some water, which he drank with eyes fixed on the foe. His plans were formed. Should the puma come on the plank, Androcles would move to the other end and upset his majesty into the well. Should he decide not "to walk the plank", but saunter near to prepare for a spring, Androcles would himself drop into the well – the water was not deep.

But all at once it struck him that the puma might be as glad of a drop of water as he himself had been. Instantly a bucketful was poured into the trough, our friend retiring to the far end of the plank. Leo accepted the courteous offer, and stepping cautiously forward, drank eagerly. He was very thirsty. Having quenched his thirst, he gave his benefactor an unmistakable look of gratitude; he then turned and walked away back along the same road they had come together. Androcles with a rare sense of relief, and reflecting on the potent influence of kindness over the ferocious instinct, stood eyeing him till he had entirely disappeared in the distance.

Androcles - the ex-leader Lewis Jones - is now gone; with the same ship went the petition of the Colonists to the Governor of the Falkland Islands asking for removal to a British possession.

Meanwhile the Mud Settlement gave attention to internal affairs. They could not understand the non-appearance of the Indians. Oft-times at night strange noises startled them, which they interpreted as signals between some prowling Indians. In the day time the columns of dust blown in and out of distant ravines or seen waltzing with the whirlwind far away on the pampa, were indications that Indians were out on the spy. In fact, the Indians were getting on the nerves of these Settlers. "Let us end this tantalizing suspense by sending a strong well armed party into the interior along the Valley" said they. A number of well-equipped men went on horse-back. They were absent for a fortnight. They reported that after a few days' march due west an impassable barrier of rock running north and south and of great height confronted them. Through this barrier the River had cut itself a narrow channel along which they could not pass, nor could they find any path leading through, or over this barrier of granite.

Their inference was that the Settlers were located in a Valley isolated on the coast, and cut off from the interior so effectively that no Indians could surprise them from the west hinterland. This discovery with its inference, supplied excellent tonic for the nerves of the battlement. The people began to settle on the farms marked out by the Government Surveyor who had come along now assuming its wanted role.

The first wedding was about to be celebrated, it was an event of great interest, and all the settlement prepared to conduct itself with becoming hilarity. The old country tokens, presents and ceremonies were conspicuously absent, but genuine expressions of joy at the happy event with congratulations and felicitations in various styles, novel and strange, were not wanting, and an accredited Minister was in their midst. But surely Cupid and the Fairies, that are supposed to have their role to play on these occasions, are not going to let this first marriage of civilization in Patagonia be celebrated without intervening to lay a significant emphasis upon the ceremony! Will these ubiquitous and occult imps be caught napping?

Look! What is this? Behold a rider in a cloud of dust is flaring towards the Settlement. Arriving he shouts - "The Indians are coming". Staring westward a small party was seen making for the old Fortress. It was coming on cautiously yet steadily at a jog trot pace. It consists of four. They are Indians; it is evident by their garb. As they get near it is noticed that one is an elderly man, and he is accompanied by an elderly woman and two young women. The Settlers are standing about in groups as the four fearlessly, but gravely, ride into their midst. Scant leisure had the Settlers to get over their fright and to put a bold face on.

It was an embarrassing situation. There was no common language, but signs to dismount were obeyed, and offered food was gratefully accepted, and immediately partaken of with manifestations of gratitude. The old woman then proceeded to a fine bush of pampas grass near by, and gathering some twigs into a heap against the bush she took out her tinder-box and set the bush ablaze. The long spiral column of smoke

ascended for a silent witness to concealed warriors - as was afterwards made known - who on the distant hills were watching the reception given to their cacique. The old man who so unostentatiously and so absolutely unprotected, had come into their midst, was no other man than the honored chief of the tribe, who were the rightful owners of the soil which the Settlers had come to possess. The Indians problem now demanded instant solution. Meeting was convened and the question put - "How shall we treat these Indians"? A momentous question, and no time for discussion. Life's greatest questions are of this kind, and the answer to them must come with the speed of the lightning flash. One suggested the destruction of the Indian Party, - in order that the other Indians might not come to know of the existence of the Colony. This proposal met with the contempt it deserved and another resolution was proposed and adopted: To treat the Indians as we treat each other and even to extend to them, as we do to children, the leniency due to ignorance.

This was substantially the decision arrived at and acted upon. It is worthy of record, and should be written in letters of gold in the history of colonization. It was at once sane and magnanimous. Even the Quaker settlements of Pennsylvania did not excel it.

This handful of Colonists declared thus - that they regarded the murder of a savage as heinous fratricide - the pouncing of inventive Cain upon defenseless Abel. The Mud Settlement had struck the highest note!

Never was there a more short-sighted, idiotic policy than that of seeking to advance civilization by the ruthless destruction of the aborigines. The native is the product of a steady process of evolution. Anthropology

and geography teach us that every locality has its subtle touch upon the development of man. Incalculable losses to the robustness, simplicity and straight forwardness of civilization, are incurred by the insensate cancellation of the native element. The native is capable of becoming a real benefactor. Bred in his bone and blood are traits and qualities needed to enrich the human stock. These priceless legacies of centuries, possibly millenniums, have been wantonly, and with shocking cruelty, spilt on the ground. The health and vigour of civilization demand their preservation and study.

The humane and sensible reception given by the Settlers to this Indian family was well repaid. It procured advantages of immense value to the Colonists in passing through a most critical stage in their history. It soon became painfully evident they were cut adrift from civilization, and it was necessary they should know how best to make profitable use, of such resources as lay immediately around. The nearest community - a small and poor one - was that on Rio Negro. It could only be reached by sea. To attempt it by land was unthinkable. To keep the ship – which was not their property - going, required cargoes, which as of yet they had not. The Argentine Government was in a weak state, and getting tired of continually helping the Settlers. The Indian who had so unexpectedly settled down near the Colonists possessed a good number of horses including breeding mares and colts, and a number of dogs. He had pitched his tent fairly near, so that a close intercourse grew up between him and the Settlers. Being one of the principal Chiefs of Patagonia, he conducted himself with becoming dignity. Besides, he was naturally shrewd and observant. His kindly disposition, gradually won the trust and even the affection of all.

Francisco - so he was called - reciprocated both trust and affection, and bartered abundant game for bread and other things. Mutual confidence having been established, he taught the Colonists how to manage the horses and the cows, how to use the bolas and lasso, and how to turn the raw hide into whips, lassos, (ropes) fetters, halters and saddles. They learnt of him also the mysteries of the preparation of puchero, asado, and many other necessary items of value in their new culinary and changed life.

One day he ventured to suggest that the young men should come along with him to hunt the ostrich and the guanaco. The valley was fairly well stocked with these wild animals, but the Colonists could only get one occasionally by shooting. Ammunition was getting too valuable to be used up in this way. Come with me, said Francisco, and I will lend you horses and dogs, and will show you how to surround and entrap these wily and fleet creatures of the pampas.

His offer was readily accepted by the younger man of the Settlement, for every particle of fear, or suspicion of the Indian had passed away by this time. Francisco was himself considered by his people an expert huntsman, and under his able and sympathetic tuition, our young men became Nimrods of the chase.

They looked forward with joy to a day of hunting under the direction of Francisco. Mounted on his well-trained horses they would scour Valley or pampa for quarry, and the Settlement was well supplied with meat. Exhilarated by chase and pampa, the men returned to their fortress home, dispersing clouds and discontent as they rode in bringing their quarry behind them. These

hunting expeditions were opportunely beneficial in relieving the monotony of the somewhat cramped and dissatisfied routine life in the Fortress.

The season was much too far advanced to encourage them to put much labour on the land. There were few who had selected what seemed to be favorable spots, and with pick and spade ware doing a bit of experimenting so as to be better prepared for next season. They could muster a plough or two, but there was not a horse trained to draw it - possibly not one could be found in the whole Republic. The little ploughing that was done anywhere was done by means of oxen. This method was much too primitive for these Settlers even had they the oxen, which they had not. Francisco's coming at this juncture was regarded as providential. With what enthusiasm did the younger men throw themselves into this new experience of hunting! In Wales, it was the closed privilege of squires and rich landlords. And what a fuss they made of hunting down a poor fox! They fed high-bred horses and a host of dogs, to run down an occasional reynard reared for the purpose of this sport. Many a farmer cursed them as they went through his fields. Among these Settlers were farmers who had suffered in this way. These Colonists are now privileged to hunt, and they do it for the common good, injuring none.

At first the return of the huntsmen was quite an event. Old and young would come in groups and share the spoils. The huntsman would rage regale them with tales of the chase of the prowess of their leader Francisco, his marvelous dexterity with bolas and lasso, the fleetness of his horses, the cleverness of his dogs and most of all his kindness and patience with the inexperienced "gringos". Of course they had wonderful

adventures, narrow escapes, wonderful falls and tumbles - but not a bone broken. The Settlers were not long in acquiring a liking for their novel food. Game was reserved for the gentry in the old country, now the Settlers are privileged to enjoy it in a abundance and variety.

The animal which figured most in the quarry was the guanaco, the ancestor, we are told, of the camel. It is, however a much smaller animal with much the same gait as the camel, and is widely distributed through the whole of South America. To the natives it is by far the most useful and valuable of all the animals. It provides them with house, food, and clothing. The toldo, or tent, is made of the skins of old animals sewn together and thrown over poles stubs firmly in the ground. The bedding consists of skins of younger animals sewn together to the size of an ordinary blanket. There will also be some coarse loosely woven rags which the women: weave, using the long wool found on the older animals. The mantles - called quillango - which is often the only garment worn, is made of a number of skins of very young, or newly dropped, guanaco. The long neck makes the boots which come far up the leg. Whips, rains, halters etc., are made of the hide of old animals. The sewing is done with the sinews drawn from ostrich legs, which can be split to any required fineness.

The ostrich is not the familiar bird of Africa, nor yet the American ostrich but is a real native of Patagonia and peculiar to Eastern Patagonia. It was discovered by Darwin, and is named Rhea Darwini. It is nothing like the fine feathers of the African ostrich, and no pretence of a tail. Though a much humbler bird than its African cousin is, yet it is of much value to the native. The

feathers are profitable commercially as the feather brushes used in certain establishments are made of the feathers of the Rhea Darwini. The most valuable are the grey feathers found in the wings of the older birds and these feathers are respectable enough to undertake for some purposes, the more lucrative role of the real African ostrich. The Rhea also differs from the African in having three toes. When chased, the Rhea Darwini can use the tactics of the African ostrich most effectively. If he can get the wind on either side he throws up one wing for a sail and thus like a miniature ship it sails across the plain at an incredible speed! It also dodges pursuit by change of direction and wing. Ostrich meat is well relished like that of the guanaco and is a very welcome change and substitute, on account of having more fat about it, while the guanaco is almost always lean; and fat is one of the essentials of camp cookery.

The swift-footed hare or cavy, also abounds on the pampas and is quite an important item as a quarry. It furnishes fair amount of meat, and it is considerably larger than the hare in the old country. The flesh is good, though very dry. These rodents are to be found in all parts of Patagonia. They, like the rabbit, make a burrow in the earth, and when chased run in a circle for the burrow. Then comes the little armadillo, not at all to be despised. Here one gets a good amount of fat, and the meat, when properly roasted is very fine eating. When powder end shot can be spared there are guineafowl, partridges, wild ducks and geese in abundance. And no game laws! In the midst of this abundance of game, without restrictive regulations or notice boards with the warning "Trespassers will be prosecuted". Without suspicious constable or game keeper cogging one's footsteps on moorland or

river-bank, the Colonists were gradually realizing the change. "They were like them that dream. Their mouths were filled with laughter and their tongues with singing".

A group was enjoying a smoke in the still evening twilight, when, one broke the silence with: - Bob do you remember that night when you were on duty as keeper at - -?" "Don't I, Will; but you were not among those poachers were you?" –"Indeed I was". We nearly did you in that night Bob and you well deserved it all. But I am glad you got through safely. We will now shake hands as Brother freeholders and freemen".

Chapter 6

John Bull Looks In
Then an Indian Invasion

Britishers in their roamings and adventures in foreign lands are encouraged by the knowledge that the sleepless eye of John Bull is resting upon them everywhere. John has a knack of finding out a British subject in distress.

The Welsh Settlers had begun to fear they had been shunted aside in a lonely valley, in the solitude of the illimitable expanse of the Patagonian plains. Here on the tail end of creation even the eye of John Bull would not fall on them. What a surprise they had one morning when the accents of the Queen's English fell on their ears, "How do you do here?"

The British ship Man of War, *Triton*, had just anchored unannounced at Port Madryn. It was early in July 1866, before the settlement had celebrated its first anniversary. The Governor of the Falklands had duly received the petition sent to him containing a dismally exaggerated report of the state of things in Chubut. Nevertheless, it worked the oracle.

The Governor having made all possible inquires, forwarded the petition for the removal under the British Flag, to the British Minister in Buenos Aires. The Ministers consulted the "British Naval Station" at Montevideo with the result that a Man of War was especially sent to do the inquires on the spot.

This ship was under the command of Lieutenant Napier, and on board was Captain R. G. Watson, Secretary of the British Embassy in Buenos Aires. In order to be correct and lest any offence be given to the Argentine Republic, an Argentine Official was invited to accompany them in the *Triton* to Chubut. The name of the official appointed was Arenales.

These officers spent several days in the valley and made a thorough investigation into the causes of complaint and the prospects of the Colony. A Government Report was published in Great Britain of this visit to the settlement on the Chubut. This Report throws the petition on one side as a false statement. It also says that the Settlers wished to remain and were satisfied with their condition. It praises the valley and regards the soil as rich and adapted for pasture or tillage. The report notes also that the Settlers had then 60 acres of wheat growing and promising well. The industry of the people was remarked upon as very satisfactory, having transported a great amount of various things from Port Madryn and the mouth of the river, built houses and fences, and constructed ten miles of roads. Laziness could not be put to their charge. Many heads of families admitted they had plenty to eat, were in excellent health and had prospect of an adequate crop in 1867.

This visit rendered immense satisfaction to friends in Wales, and was of splendid service to the Colony. It also dispelled the clouds and feelings of solitude and loneliness that were so depressing. But the Colony benefited substantially in other ways. It was noted by the visitors that the Settlers were badly in need of boots, shoes and clothing. A great many pairs of seamen's footwear were given by the Captain of the *Triton* to the

most needy. What touched the Colonists most of all was the gift of 1,000 yards of flannel that the sailors had bought from the Ship's store with money collected amongst themselves.

After the visit of the *Triton*, a spirit of content drove away the whining spirit of dissatisfaction and fault-finding. All realized that they were not forsaken, or left adrift in the desert. They bent to their tasks full of hope and determined to do their best to make the Colony a success. It was the first visit of the British Navy, but the officers promised to keep an eye on the settlement and they have since paid many a visit.

In gratitude the Settlers can only say "DUW GADW SHON DARW" (God Bless John Bull). *"Many nations have done worthily, but thou hast excelled them all."*

The frequent visits of the British ships of war on duty on the far off South American station in those early years always meant a holiday in the Colony. Generally a hunt was arranged in which the officers joined and thoroughly enjoyed a day's sport on the pampas of Patagonia. Some illustrious officers in the British Navy today will recall those pleasant hours.

Among the names of officers who went down in the flagship *Victoria* in the Mediterranean, I found that of a fine gentleman who was on the Garnet, while on this station, and with other officers visited our settlement. Others today shed luster on the highest seats of the Empire.

The *Triton* had only been gone a few days when the Colony was surprised by other visitors quite unexpectedly. The Indian Chief Francisco and his

family were still in the Colony and his stay was proving a great boon.

One Sunday afternoon the Minister Rev. A. Mathews was holding divine services in a dwelling house, some ten miles up the river from the Fortress. The Settlers had by this time begun to settle upon their selected plots of land - some 120 acres – granted by the Argentine Government.

The house in which the service was held, was the farthest up the valley. Suddenly the house was surrounded by Indians in great numbers with droves of horses and a multitude of dogs. Some got into the house, others crowded about the windows to stare at the congregation.

The Service was drawn to an abrupt close and, as the minister and congregation came out, it seemed as if hundreds of Indians had come up to them. Instantly a messenger was dispatched to carry the news to all the houses on the way to town, as the neighborhood of the Fortress was beginning to be called.

The Minister mounted his horse and started to his home near the old fortress. The chief of the tribe with other Indians accompanied him. Rev. Matthews had acquired a few Spanish words, but conversation to any purpose was not possible. The Colony spent a sleepless night, but nothing untoward happened. And the tribe showed great wisdom and consideration for the Settlers by camping some six miles above the town on the north side.

Men had been on the watch all night, and right glad were they when the morning came to find that nothing

to alarm them had taken place in the night. About midday they found the Indians had come nearer, and were pitching some fifteen tents close to the little town. The tribe turned out to be Pampa Indians, who roamed to the North of River Chubut. The Chief was Chiquichan and their number on this occasion was about 70 men, women and children.

The Colonists had scarcely recovered from their surprise, when it was found that another tribe had come down on the south side of the river. In strength and number it seemed equal to the tribe on the north side. It was a different tribe altogether and was known as Tehuelches and lived to the south of the river. Their Chief, who was with them, was called Galatts. They pitched their tents on the south side, just opposite the tribe on the north side.

It all seemed very strange to the Colonists, somewhat like an invasion and executed with deliberation, firmness and skill. It was known that Francisco had come to dwell among the Colonists so as to school them into the ways of the Indians. The Settlers were less terrified at the coming of these two tribes than they had been at the coming of Francisco and his family. Now Francisco could act as a go-between and interpreter.

Still the situation was sufficiently alarming, for the Indians far outnumbered the Colonists, who now found themselves hemmed in between two hosts of Indians and the sea.

There was nothing for it but to carry out scrupulously their line of policy, decided upon when Francisco and his family came. That decision had stood them in good stead, had endured the test of several months

experience. Its wisdom was now more evident than ever. The new comers soon made themselves at home and began visiting the houses to barter rugs, skins, ostrich feathers, horses, mares, ponchos, quillangos (guanaco skins).

Tehuelche Indian Chief, friend of Rev Rhys.
In his Memories he identified him solely as *Tehuelcho*

The Indians were keen traders. Visiting the Colony on the Rio Negro and the few people that lived at Santa Cruz in the south, they picked up a fair acquaintance with camp Spanish. Their bane was the craving for

drink, acquired in their dealings with traders. It was their great disappointment that they could get no drink at the Welsh settlement.

The surveyor had left behind three bottles of gin when he returned to Buenos Aires. A Chief was delighted to receive these, as all the drink the Colony possessed. These could not do much hurt and a beautiful mare was received in exchange. In spite of their fear at their coming, the Settlers profited greatly by the Indians of whom rugs and many horses, mares and dogs, were obtained in exchange for various articles of food and whatever else could be spared.

More than commercial gains accrued to the Settlers from the protracted stay of the Indians. The Settlers got innumerable opportunities of close acquaintance with these children of the Pampas. Their ways, habits, and customs were well under observation. Their likes and dislikes were carefully noted. As disposition of mutual kindliness and trust was cultivated, and a useful common tongue—a jumble of Welsh, Spanish and Tehuelche words grew apace.
At first the thievish propensities of the Indians were very trying to put up with. Very much like little children, they would pick up articles such as spoons, knives, etc., and concealing them in the ample folds of their mantles, march out of a house with the spoil.

The Colony soon found a remedy for their propensity. They would good humorously take hold of their mantle as they went out, and shake it well. As the article fell to the ground, the Indians and the Colonists would laugh together over the discovery, and no more was made of the incident. If however, any serious misbehavior was

committed, a word sent to the Cacique brought a heavy chastisement upon the culprit.

During a subsequent visit of this tribe, we had an example of this punishment of an offender by the Cacique. The Indian, while the worse for drink, endeavored to force open the door of a farmhouse. The farmer had noticed him coming towards the house and seeing he was drunk had shut the door and bolted it. The Indian knocked and called, but getting no admission, tried to force it. Failing to do this he plied his dagger in the openings between the boards trying to get at the farmer who pressed against the door lest the bolt should give way. The farmer managed to dodge the dagger, and the next morning reported the affair to the Cacique, pointing out the culprit. The Chief called up the culprit, and after a few words of censure, took his horsewhip, and in the presence of the tribe, administered such a castigation as the fellow would never forget.

The Colonists treated the natives consistently with much consideration and with wonderful patience and indulgence. Yet they deemed it wise to be firm, and never to permit wrongdoing or tolerate undue advantage being taken. This firmness was put severely to the test when after three months stay the Indians began to break up the camp to retire to their hunting grounds in the Andes Cordillera. Having spent the latter half of the winter in Chubut, the advent of spring called them to the chase.

A strong portion of the tribe on the south side suddenly left as a vanguard with a great number of horses. In a day or two after this departure, the Colonists found

several of their horses missing. They immediately concluded that the Indians had taken them.

The president of the Colony at once saw the Cacique who remained with the rearguard and charged the departed Indians with the horses. He also said that the Chief and his family would be kept as hostages until the horses were brought back. The Chief took it calmly enough saying that possibly the Settlers' horses had got mixed up with the Indians' horses and that the young men had not noticed their presence in their great drove. He would gladly lend horses to the Colonists to pursue his people and as they could not be gone far away, they would soon overtake them and get their own horses separated and restored to them. "Certainly," said he, "my people have no idea of stealing your horses."

His offer of horses and also of guides to go in pursuit was accepted and a number of young Settlers went together with the guides up country. They soon overtook the Indians, but somehow the Indians resented the charge of robbery and insisted that the horses had gotten mixed. The resentment grew somewhat bitter. Had the Indian guides been absent, the affair might have been serious. To aggravate the situation, an Indian, Paul Pry, meddling with the stock of a rifle carried by one of the pursuers, inadvertently pulled the trigger. The rifle was loaded but fortunately the charge went out into the air.

The Indians got greatly excited. Here the good officers of Orkeke, the Indian who traveled with Captain Musters, and is mentioned in his book, succeeded in calming the excitement and restoring goodwill. The horses were restored also, and both Indians and

Colonists parted on good terms and no bad blood was made.

No one was more pleased than the Cacique Galetts to see the Colonists and the guides returning and bringing the horses back again. In a few days after this, the Indians on both sides of the river had departed for the Hinterland, leaving no ill feelings and bearing an excellent opinion of the strangers who had come to their home in one of their fertile valleys.

The advent of the Welsh turned out to be an event of much benefit to these Indians. The leaders of the settlement brought their case before the Argentine Government as deserving recognition by way of rations. It was an excellent move to cement the good understanding now established between the Colonists and the natives.

The Welsh were also anxious to preserve these excellent relations so as to rob the government of every pretext for the erection of a frontier fortress between them and the Indians. Against this provision they have consistently protested and that successfully.

This invasion of the Colony by Indian tribes simultaneously on both sides of the river has been and will continue to be an inexplicable mystery to the Colonists. Such a conjunction was never seen again in such strong muster. Here were the giant nomads of the Southern side of the Chubut roaming far down to the Straits of Magellan and up to the foothills of the Cordilleras. Fine muscular men, fairly numerous and brave warriors. Again on the other side of the river, we had the restless and ruthless Pampa Indians who had

been for generations the terror of Spanish settlements within their reach.

Between them these tribes claimed the whole of Eastern Patagonia as their rightful territory. Besides, they had successfully defeated every attempt to colonize any portion of it, either on the coast or in the Cordilleras. There are traditions of various attempts at colonization, and there are still vestiges of these attempts to be seen today in various parts of Patagonia. But the Indians ruthlessly wiped them out. A particularly promising settlement was started at the Valdes Peninsula between New Bay and the St. Joseph Bay. The Indians surprised them on a Sunday morning, killing the men and taking captive the women and children. Indeed, ever since the settlement of Chubut, the Pampa Indians have committed depredations and murderous attacks on portions of the Rio Negro Colony.

It is not surprising that some consider this singular, simultaneous or concurrent invasion of the Colony to have been the prelude of a pre-concerted attack and destruction of the settlement. The behavior of the Colonists, however, had completely disarmed the Indians, and a prolonged stay amongst the Settlers had won their hearts and turned their wrath to praise and admiration. That this inference is reasonable may be assumed from the following incidents:

As the Indians were leaving the Colony after their stay of three months, they asked the Settlers "Who are you, for you are not Christians!" "Yes" said the Settlers, "we are Christians". "NO" they said, "we know Christians having met them in other settlements. They are cruel to us, rob us, steal our horses, and kill us when they get the chance. You never do so. You buy and

pay for what you get. You have never stolen one of our horses. You have never injured us. No! We shall not call you 'Christianos', we shall call you 'Galenses'" (Welshmen), and to this day this distinction is made between the Settlers of Chubut and other white men, by the Patagonian Indians. How the excellent name of Christ is blasphemed on account of the unworthy deportment of those that bear it!

Again, some time after this, Francisco was one of half a dozen Patagonian Chiefs invited to Buenos Aires to arrange matters in regard to rations voted for their tribes by the Government. Their mission was successful, but Francisco took fever and was taken to the hospital. He failed to rally. And as he was dying, he surprised the nurses by saying aloud in his broken Spanish. "I am going to the heaven of the Galenses, for the place where these good people go to must be a happy place."

Monument to the Indian, Madryn, Chubut

Chapter 7

The Mud Settlement Breaks Up

The life of excitement enjoyed by the Settlers during the lengthy stay of the Indian Tribes produced a disposition that would not readily re-adjust itself to the humdrum lot of Hodge. Moreover, most of the Settlers came from industrial district where variety and quick returns prevailed. They lacked the husbandman's long patience.

Not a drop of rain had fallen since the visit of the *Triton*. When they took the Deputation around to view the wheat patches that dotted some of the riverbeds, these were found to be very promising and of a splendid yield. The result, however, was a disappointment. For lack of rain, the early promise withered away. This failure of the wheat crop was a bitter experience. Much honest labor had been expended on those patches, for every inch was stubborn glebe.

Selected because of the growth upon it, which was evidence of its fertility, much digging up of roots and clearing of bush had been necessary to set it into a fit state for the sowing.

This checkered experience with its alternations of hope and disappointment tried the Settlers very sorely. It revealed the perverseness of the human mind, which kept clinging obstinately to old ways and methods, while it should have studied the new phenomenon and novel environment in which they were placed.

The Colonists had intended this harvest to be a fair test and had carefully prepared ground which had already proved fertile. The reward of all the labor and diligence was failure. Failure everywhere except where the tide had pushed the river over its margin here and there so as to give an occasional wash of water over portions of the patches. Here a little wheat came to maturity. It was a hint of Providence that should have opened their eyes. But they regarded the whole valley, except the margin of the river, as soil incapable of bearing any growth whatsoever. Imagine the sea beach walled periodically by the waves, and imagine the sand to be black or brownish hot and dry and you will get some idea of the soil of Chubut valley when the Settlers arrived there.

A conference followed this fiasco of harvest, and all the land of the valley was condemned as unfit for cultivation. An exploring party went up the valley for many miles and returned with news of no better land. Decision was thereupon made to give up the idea of settling in the Chubut and to petition the Government to remove the Colony to some other part of the Republic where they could settle.

This was a very grave decision. It meant the giving up of an enterprise that had cost thousands of pounds in its initiation and had stirred the thought and fired the imagination of Welsh patriots in Great Britain and the U.S.A. for some years. Besides it was an exceedingly rash decision. They had not yet been two years in the Valley and had really only tested the green margins of the river. The broad extensive flat stretches of land lying between the river and the low tableland on both sides having a forbidden aspect of ashen hue – a turfless

waste – were taken for granted as beyond dispute, barren and unproductive. The land was condemned untried.

These men, enthusiasts on banks of the Mersey less than two years ago had become crass wrecked on the banks of Chubut. As the excessive mud in the Fortress community had depressed them into complaining and petitioning to the Governor of the Falklands barely a year ago, so the exciting experience and rollicking times with the Indians on pampa and valley hunting ostrich, guanaco and puma, now reach upon the spirits of these same people and disaffection and petitioning becomes ripe once more.

Steps were immediately taken to carry out this decision of seeking a new place. On the beach at the mouth of the river lay the little ship *Danby* just where she was driven ashore some months ago. She must be overhauled and if possible made seaworthy. Among the men were a blacksmith, ship carpenters and joiners who could do the necessary repairs. Near the *Danby* was another wreck of a date prior to that of the settlement. Here were found supplies of timber, iron, etc suitable for the work of repairing the little ship. Fairly good smithy was extemporized on the beach, and craftsmen got busy in and about the ship. Relays of willing helpers kept going, bringing wood and iron to the busy craftsmen, thus maintaining a merry industry on the seashore for sometime.

While repairs went on, the "Capital" was transferred from the Old Fort to the little ship. Many a meeting of paramount importance held in the "Town Hall" the nickname of the hold of the ship. The spot where the envil stood and the sparks flew lost nothing of the

raciness and attraction of the proverbial village smithy. Most of the men were quite jovial and working with a will. The Chubut Valley had lost every shred of interest to them, as they were waiting for the next turn of the kaleidoscope. The ship being now ready, a meeting was convened to elect a Deputation, to negotiate with the government the removal of the settlement. A Commission, to visit and pronounce opinion on any new land offered from Buenos Aires, arriving there early in February, 1867.

HOW CAME THE TUG OF WAR:

The leader of the Colony enterprise since leaving the Mersey was Mr. Lewis Jones. Disgusted with the discontent in the Mud-Settlement, we saw him leaving Chubut about three months after the arrival of the immigrants. He settled in Buenos Aires where he got on the stage of the Buenos Aires Standard. Here he made friends and picked up Spanish and learned to understand the Argentine character and the ways and etiquette of native officialism. This was excellent preparation for the role he was destined to play for many years in connection with the Colony.

Hearing that the little ship from Chubut had arrived in the harbor of Buenos Aires with a special Deputation to the Government, Lewis Jones instantly and earnestly resumed the role of leader and entered into the negotiations with a view to defend the intentions of the wreckers.

Mr. Jones was well known to the highest foot officials, especially the Minister of Immigration, and very wisely, these resolved to be guided by him in the negotiations. Lewis Jones threw himself heart and soul

against the suggestion of removal and got Dr. Rawson, the Immigration Minister, to expose his view. Rawson had been a party in the negotiations respecting the Settlement from the start and was a stout champion of the movement on the Argentine side. The contest with the Deputation from Chubut was a stiff and delicate one lasting three months. But Dr. Rawson prevailed, persuading the men to return to Chubut and induce the Settlers to consent to yet another year's trial.

Meanwhile, the Commission, which had been dispatched by the Colonists to find a new place for the Settlement, came to Buenos Aires to report the promise of land at "Pajaro Blanco" in the province of "Santa Fe". On their arrival, they were informed that the Colonists had already promised Dr. Rawson to return to Chubut and make another effort.

Accordingly, the Deputation of Colonists got ready to embark for Chubut, when some misgiving was expressed about the seaworthiness of the little ship. The British Minister, at their request, graciously had it examined with the result that it was condemned. The Argentine Government then sent the Colonists by steamer as far as Rio Negro from which place they would be taken in a sailing ship to Chubut.

Meanwhile, the Rio Negro authorities, learning of the discontent and the decision to remove from Chubut, made an offer to the returning Deputation of land high up the Valley of the River Negro. The Deputation was taken 100 miles up river to see the proffered land. This they found to be very similar to the land in the Valley of Chubut. The river was sinuous with many bends and curves and between it the tableland on either side. The soil was dry and barren as in Chubut.

Having arrived in Chubut, the Deputation submitted the three proposals to the Settlers, urging acceptance of that of Dr. Rawson. Failing this, they submitted the report of the Commission on the offer of the Government of "Santa Fe" and their own report on the offer of land in "Rio Negro."

The Settlers, by a large majority, decided not to remain in Chubut, in disregard of Dr. Rawson's general proposal, preferring instead to accept the offer of land in Santa Fe.

The same ship took the Deputation back to Rio Negro whence they would proceed to Buenos Aires to report to Dr. Rawson. While quietly sailing up the Negro River and about the case anchor, the Deputation was surprised to see the Chubut ship *Danby* sailing up the river in their wake.

Mr. Lewis Jones, together with a Mr. John Griffiths, a quondam member of the Liverpool Committee, had persuaded a certain Captain Neagle to take the condemned ship down from Buenos Aires to Chubut.

The Deputation understood at once when they heard that Mr. Lewis Jones was on board, that a formidable countermove to Santa Fe scheme was set afoot. The leader of the Deputation and Mr. Lewis Jones were bitter antagonists in policy. Having anchored not far apart, they remained for some days without speaking to each other.

At last, the leader of the Deputation resolved to see Mr. Lewis Jones and discuss matters and if possible arrived at a common understanding in regard to the points of

serious differences that had arisen. The interviews were long and sometimes heated, but continued until both leaders agreed to sink personal differences and devote themselves to cooperate on a common policy.

This policy being the preservation the unity of Colonists and the prevention of their breaking up into small parties to be dispersed among the native population which was aligned in tongue, religion and civilization. The situation demanded this compact of these two patriotic leaders. In consequence of it, the Deputation abandoned the intended visit to Buenos Aires and having written to acquaint Doctor Rawson of the agreement, both parties now went together down to Chubut in the little ship *Danby*.

The compact had not come one moment too soon for on dropping anchor in Port Madryn, the eyes of the Deputation fell upon a scene that filled them almost with despair. The ruin of the Settlement was accomplished.

All around the land wharf laid heaps of farming implements, rifles, household utensils, packages of salted meat and various other materials. Also the Settlers improvised shelters and a few cattle and horses grazing about close by. The Settlers had evidently deserted the valley of Chubut and came to Port Madryn to await shipment to the new land offered them in the province of Santa Fe.

On landing, a mass meeting was quickly commenced when the Settlers stoutly opposed the Deputation's suggestion that all should return to the Valley. Thereupon, the Deputation pointed out that the season

was already too far advanced for the Settlers to get any advantage from the land offered them in Santa Fe.

Then reluctantly the Settlers abandoned the idea of settling in Santa Fe but proposed the alternative settlement offered to them in Rio Negro. It was then decided to send representatives to Rio Negro for more exact particulars of the conditions and prospects of settlement there. These representatives, however, on their return failed to give a satisfactory report.

The Deputation was quick enough to immediately take advantage of this moment of disagreement and uncertainly and prevailed on the Settlers to return to Chubut Valley. They comforted themselves that it was not now the task of two years. Now the road was good and could not be missed. They were also fairly well mounted on horses.

The crisis over, it was decided to make this a red letter day. They would celebrate together when they left Port Madryn, the landing of the immigrants two years ago. It was the Anniversary of that event of July 28th, 1865. In its way, it was a memorable day. The Settlers, some representative Indians and the old leader Lewis Jones among them once more, formed a combination that promised better times. That celebration on the beach of Port Madryn was a day of enthusiasm.

Mr. Lewis Jones returned to Buenos Aires to report success and present a memorial to Dr. Rawson stating the required necessities for the restart. He took with him also some representative Indians to arrange with the Government for rations for their tribes, in compensation for land taken. On his way, he called at Rio Negro and arranged for the loading of the ship he had come by, the

Danby, with a cargo of necessities to be taken as soon as possible to Chubut. Having done this, he went to Buenos Aires.

Lewis Jones , the leader of the colonization and founder of Trelew (Town of Llew) in 1890. Trelew is the largest city in the Province of Chubut.

Dr. Rawson was gratified with the good news that Lewis Jones had brought of the acquiescence of the Colonists in his proposal. He promised to do all he could to secure more regular communication with the Colony and to supply it regularly with the provisions promised.

Mr. Jones spent some months at this juncture, voyaging to and fro between Buenos Aires and Rio Negro expediting matters concerning Chubut. The Colony was greatly reinforced at this time by the coming of excellent new Settlers. One family of nine came from Rio Grande Do Sul in the Brazils, remnants of the abortive attempt to form a Colony of Welshmen there two years previous to the settlement at Chubut. Another family of three came from Oneida, U.S.A., and

a young farmer arrived from North Wales. There were typical instances of the way in which the ideals of the Colony appealed to Welshmen everywhere. These fresh immigrants had wide experience of agriculture and became successful Colonists.

A dire calamity now intervened. After the return of the settlement from Madryn to Chubut, there had been a lull in the communications with Buenos Aires, and the settlement had run short of necessities. It was felt that the little ship *Danby*, though condemned, might be prepared for another voyage to Rio Negro for supplies. Captain Neagle would take it, and five Colonists volunteered to go with him as ship hands. There was also a passenger of some importance on board, a Mr. Cadivor Wood of Chester, Secretary of the newly formed "Emigration Company" of Liverpool and registered to trade with the Colony. The *Danby* arrived in Rio Negro, and after having received cargo, sailed on her return voyage for Chubut on February 16th, 1868.

The return of the little ship was fully expected before the end of February. As time went on, friends in Chubut began to fear the worst. Everyone knew it had been condemned as unseaworthy. No ship called in March or April. In May, a ship arrived with supplies from the Government. By it came tidings that the Danby left Rio Negro for Chubut on February 16th. The missing hands belonged to families in Chubut so that the blow was quite a tragedy, throwing the Colony into deep sorrow and mourning.

Years after there was a rumor that seal hunters had found, far south of Chubut, a grave with human remains near it, together with articles known to belong to some of the lost men.

Chapter 8

Aaron Jenkins Makes History

The Settlers with their surviving stock, materials and luggage reoccupied the Chubut valley in August, 1867. Meanwhile, Lewis Jones in Buenos Aires gave himself wholeheartedly to the task of expediting Government supplies promised for the Colony.

Until the arrival of these supplies, the Colonists had to subsist on the dairy produce realized from the few livestock that had remained - a reminder due to the obstinacy of a few Colonists who could not be made to believe that an exodus would really take place. They could not be persuaded to kill and salt their stock in anticipation of a voyage.

After the departure for Port Madryn, the Indians had visited the Valley and finding it deserted, they let themselves go in fun and frolic, burning and smashing up on every hand. How the returned Settlers were grieved when they faced the blackened dilapidation that had been their homes! How they missed the lowing of the cattle and the bleating of the calves. But the thought that they were back only for nine short months comforted them. The generosity of the less rash amongst them stood them all in good stead at this juncture; for what had been preserved alive became more of a common stock than a private possession. In spite of the salted provision, there was a serious shortage of food ere the supplies arrived from Buenos Aires, resulting in much privation.

Honest preparations were made to give the land one more "Try", but profiting not by the signal failures of past seasons, they adopted the same methods and cultivated the same kind of soil that had so disappointed them.

Not so Aaron Jenkins, however; he was going to sow in accordance with his promise, but he was not going to dig and sweat on the tough land on the riverbank that had previously yielded him no increase. He sowed deliberately against many protests on the dry barren, sodless, black soil hitherto regarded as waste acres. No ploughing or clearing was necessary, and the soil was well pulverized for some inches beneath the surface. Dragging, by means of a horse, a mass of thorn bushes repeatedly across the patch, the seed was thoroughly harrowed and covered. The labor expended by Aaron in the whole operation was ludicrously small in comparison with that more elaborate preparation of his fellow-Colonists on the margin, and in the bends of the river.

Aaron's innovation was regarded as a dodge for evading the spirit while obeying the letter of the agreement. "Is not that soil evidently under the curse of nature?" For not a blade is seen to grow upon it. Hot and dry marl, in long and wide flat stretches, with cracks and fissures figuring its surface, as if writing thereon the doom of permanent sterility.

Having finished his planting, Aaron led his horse to be tethered in grass growing on the bank of the River. Here he stood in deep thought. The channel of the River was fully to the brink. Aaron cast alternate glances now on the river and then on his plot of land. He soliloquized, "If I got this water to flow gently over

my bit of sown land, I wonder what the result would be."

The slope from the River to the land seemed favorable. Taking a spade he went to the very brink and with it he opened a narrow ditch from the River. Before many yards were dug, the water was already on the surface. He so directed and guided it that it flowed gently and covered his patch of soil. Having watched until it was well soaked, he closed the portion of the ditch next to the River and went away wondering what the outcome of the experiment would be. This was in November, 1867, well into the summer season.

In about a week, the tiny points were in evidence, showing that the result was going to be favorable. A few days more and the whole plot was a lovely green carpet, for growth is very rapid in the hot summer of Patagonia. It was the only promising green patch of wheat in all the rainless valley of Chubut. All the Settlers rushed to see the strange sight and to congratulate the discoverer of the secret of successful farming in Patagonia.

The Welsh Settler of Chubut was often stung by such allusions as "casting himself off on the bleak tail end of creation". He had winced under much badinage of this type. He had, however, at length achieved two remarkable victories. First he had won the heart of the untamed giant Indian of Patagonia, whose footprint had so awed the world. Secondly, he had found the key for successful colonization of the vast Pampas and fertile valleys and the unlocking of fresh treasures of untold wealth for civilization. The riddle that baffled the attempts of four centuries to secure its solution, the

Welsh Settler had solved at last. The Sphinx of Patagonia had been slain.

The Colonists were by no means out of peril and difficulties. They would yet face and struggle through real difficulties and big experiences. But reverses would no longer daunt these resolute men.

The vision of the splendid success of Aaron Jenkins kindled into a blaze once more the early enthusiasm of the Colonists. The farms, already measured out and in actual possession, consisted of some thousands of acres of just such soil as Aaron had shown to be very fertile. It was decided to stay on another year and make a far more extensive test by cutting the labor of all the Settlers upon this erstwhile condemned soil, irrigating it in the way Aaron had done.

A report having been sent to Dr. Rawson of the success of the "Try" recommended by him last year, his further aid was solicited for yet another year that the combined labor of the whole settlement might be put upon the fresh soil and the new method.

Naturally delighted with the happy turn of events, the Doctor acquiesced and in May, 1868, a ship laden with provisions, seed and cattle arrived to hearten and enable the Colonists to turn with hopeful and united efforts to doubly ensure the success of their work. The new soil needed nothing of the hard labor expended in former years on the margin of the River, while seeking to substitute wheat for the rank and mottled vegetation already in firm possession thereon.

An early start was made after the arrival of fresh supplies in May. The plough and the harrow went

merrily through the alluvial marl that yielded as if to a magic touch that was waking it from the industrial rest of ages. The rhythmic swing of the sower's arm and his measured step as he paced the spongy soil told of the rising tide of optimism that was already submerging the records of past failures.

Never before was sowing done on so large a scale. Only the measure of the subsidy set the Unit. Every Settler sowed his bit and some very extensively. The River, as if to encourage the optimism, began to rise earlier than was its want. Carefully were the shallow ditches dug in the river bank. Careless ships might let on to the ground, instead of a manageable stream, a devastating flood. The sides of the ditch near the River had to be lined with poles driven into the soil and a padding of straw and grass pressed between the poles and the sides to prevent the gaps from becoming serious breaches. A door was placed at the entrance to regulate the flow of water as the level of the River rose or fell. The ditches were also constructed at right angles to the River for the same reason of safety.

Every farmer had not a ditch of his own. One ditch would serve a group who combined as convenience and labor dictated. All enjoyed the new experience of irrigating their fields; it was so novel and exciting. The portion put under cultivation would be divided into irregular oblongs, squares or triangles according to the level of land required. These divisions or patches would be about an acre or thereabout. A bank would be raised between the divisions just sufficiently to retain the water within the patch till it was wholly covered. A breach was then made, and the surplus water drained into the next patch on slightly lower level.

Commencing with the one at the highest level, this operation continued from patch to patch.

Between sowing and harvest, the patches were irrigated two or three times according to need. Anticipations were high. The high river rising early supplied an abundant water supply for everyone. Not many days after, the cultivated land presented a magnificent prospect, most delightful to look upon and rich with promise.

The fields were ripe for harvest early in January, and all went forth to reap and bind the sheaves. Harvesting is expeditious in the Colony, for the wheat sheds so freely if kept too long standing, owing to the dry climate and heat.

All had been cut and nearly stacked when rain commenced and continued for over a week. This was unusual at this season and disconcerting. But worse was to follow. A terrific thunderstorm broke over the Valley, bringing on a torrential downpour of rain, as if a cloud had bust, and the morning following the storm it was found that the River had overflowed its banks, and the Valley was being rapidly inundated.

There was no wind, and the wheat stacks were seen standing with the heads visible above the water. This view of the stacks inspired the hope that the crop would be saved as the water would soon run off or soak into the soil, and the sheaves would get dry again. It was vain hope for just then a strong pampero blew upon the Valley, which was now like a vast lake, lashing it into great waves. The wheat stacks were blown down, scattered and borne down the Valley in the direction of the sea. The Settlers, rushing into the flood at various

points, succeeded in saving a good deal of the crop. But the general bulk was carried before their eyes into the sea.

Never were high hopes dashed more remorselessly to the ground. To this misfortune must be added the loss of the heads of 60-70 heifers sent in May to make good their diminished number of cattle. No loss of life was incurred. Houses had to be abandoned for a few days, but the inconvenience was slight as the weather was so warm and genial.

Fortunately, the habitations in the Old Fort had been abandoned for some time, substantial houses having been built on the low hills nearby. The Old Fortress "Sweet Home" of the Growlers, was covered over completely by the water of the flood. Strange to say, this staggering blow, which one might expect to have paralyzed the settlement, had quite the opposite effect. It braced their resolution to win success.

The calamity was regarded as the accidental conjunction of the highest rise of River, cloudburst and pampero, and such union of terrific forces at so critical a moment might never occur again. The spell of the "Splendid Vision" still lured them to try and try again.

A reinforcement of their resolution may be regarded as the arrival of another shipload of necessary subsidies from the Government an arrival almost simultaneous with the disaster of the flood. The Colonists had favorably interpreted the messages of the prosperity of the field and the adversity of the flood. Elated with successful irrigation of the extensive so-called "barren" soil, the Settlers did this year what they had not done since their arrival. They wrote letters to their friends at

home inviting them to come and join them in the sharing of the bright future of the Colony.

Immediately after the flood, Lewis Jones left Buenos Aries to report on the success and the disaster. He took with him also a consignment of butter, which found ready sale in the city. Explaining the situation at Chubut to the new Government and President Sarmiento, he found it was not their turn to lose faith in the ultimate success of the Colony and the suggested removal. To this suggestion neither Lewis Jones nor the Colonists would listen.

The Government was in no mood to give further help. They even greatly reduced the monthly subsidy, declaring that it must cease at the end of the year. Nothing daunted, Lewis Jones went to Wales to urge and foment emigration to Chubut. He also wrote to the Colony to explain, urging them to sow lavishly and otherwise prepare for prospective emigration from Wales.

The Settlers threw themselves heartily to cultivate the soil and sow and water to ensure an abundant harvest for the next year. They were confronted this year, 1869, with a new aspect. The River did not rise to its usual level, it receded earlier. In consequence of this, the wheat that had not received the repeated watering yielded a poor crop. Thus the harvest of 1869-1870 was partial and poor.

The year 1870, like the proceeding year was exceptionally dry. Chubut was not exceptional in this, for the drought of these two years was serious over vast areas of South America. So the harvest of February 1871, was also unsatisfactory. The moderate rise of the

River these last two years led to more labor, the ditches were made deeper, wider and longer, so that this year of 1871 saw a great perfecting of the irrigation system.

During this same year, a party of marauding Indians swept away some 65 horses, which considerably hampered preparation for the harvest of February 1872. This crop was also poor and unsatisfactory due to the robbery of most of the working horses and the inadequate supply of water. During 1872 considerable labor was put forth to develop greater efficiency in the system of irrigation. The River had been under observation and study these last few years such as had not been the case before. While the Settlement was preparing the soil for showers, waiting and depending upon the rainfall, the variations in the rise and fall of the River attracted little attention. Realizing at length that irrigation was destined to play an essential part in the success of agriculture, the River's behavior became a matter of close observation.

The River runs in a deep channel, and the water rises early in Spring, owing to the rainfall and the melting of the snow on the Cordilleras from three to four hundred miles due west. This rising continues with fluctuations, with the approach of winter, when the level of the water begins declining, continuing to decline as winter advances. Chubut River drains an extensive tract of country from the Andes to the Atlantic. The rainfall in this vast basin is very slight and capricious. Any sudden heavy rains cause variations in the level of the River, but the high banks of the River Channel will bear an immense volume flowing to the sea. The great and constant supply comes from the melting snow. The phenomenal rainfall of Patagonia mentioned by Darwin

refers to the West Coast where the rain is very heavy and drains into the Pacific.

Preparations on a larger scale than ever before were made in 1872 in the hope of securing a fine harvest in the early months of 1873. Moreover, whilst up until now sowing had been confined to the north side of the River, this year a start was made on the south side. Two energetic young men, one of whom had been brought up on a large farm in Wales, selected a very large and clear patch of land on the south side. They opened the ditch and prepared the land in good time. The River rose early and remained at a sufficiently high level to enable the farmers to obtain the successive watering necessary. This year the results exceeded not only those of any previous year but even the most sanguine expectations of the farmers. The yield on the south side was especially phenomenal, giving evidence of richer soil.

The outcome of this exceptional crop was that this year of 1873 enabled the Colony to organize regular trade with the outer world. They now put their wheat upon the market in Buenos Aires. Its appearance created quite a stir, and it was declared to be the finest wheat ever exhibited on that market. It realized the highest prices and the house of Messrs. Rook, Parry and Company in that city promised to set up a store in the Colony to supply goods and buy the produce of the Colony.

Thus a memorable day had dawned, and a magnificent triumph was achieved after all the penury, struggle and strain of eight years. The proudest man on this day was Aaron Jenkins, the man who had a vision and thereby

incorporated his indelible name into the history of the Colonization of Patagonia.

Maen Gwyn, one of the typical farm homes of the Lower Chubut Valley, at the beginning of the 20th Century

Shearing of sheep in the Andes Zone. Establishment of Rhys Thomas circa 1906

Chapter 9

Marooned by the Fates

It never occurred to the promoters that the Colony was peculiarly liable to be marooned, and that, as thoroughly as was Robinson Crusoe on his island. That it is easy to situate a community of people outside the path of civilization came home to us recently in the case of some of the islands of Scotland.

In the early years of the Colony, this possible isolation became painfully clear. True, it was situated on the seacoast and near the mouth of a fine river. No civilized community, however, lay between them and Cape Horn – a thousand miles away! Not an estancia or a sheep run was to be found between them and the Andes. North of them, some 200 miles distant was the old Spanish Colony on the Rio Negro, the intervening miles being arid and waterless. It was practically inaccessible except at certain seasons along routes known only to some Indians and gauchos. Eastward lies the Atlantic. The great liners pass by to round the Horn or thread their way through the Straits of Magellan to the Pacific but their track lay far out of sight on the restless main.

Several attempts were made to establish regular communication by sea. Without it progress was impossible. Several little ships were brought to ply between Buenos Aires and the river mouth, but one after another came to grief and sometimes as in the case

of the "Darby" to serious disaster. One reason of the difficulty is that the River runs for some distance parallel to the beach before discharging itself into the sea. The narrow strip of land between it and the sea, running northeast shelters the river concealing the outlet from observation from the sea. The presence of a reef in the estuary constitutes a source of great danger in negotiating the entrance. The rocks also are very exposed, affording a bad anchorage. Boats have been wrecked and lives lost on this reef.

The ship we sailed was unable, on arrival, to enter the River on account of the receding tide. Deciding to put the passengers ashore, the boat was lowered. The crew was plying well at the oars when suddenly there was a grating noise and the boat got stuck in the midst of the breakers! The Italian crew shipped oars and flew at the steersman with threatening gestures. Some anxious and serious moments followed. The four passengers were the coolest persons in that boat, not understanding a word of the hot altercation and placidly retaining their seats. My wife quietly opened an umbrella to protect herself and child from the drenching spray. A fellow passenger removing his cigarillo and observing the screaming gulls gyrating overhead remarked quite coolly, "Are these gulls birds of ill-omen?" The beach was getting lined with helpless spectators. The dispute at the helm suddenly ceasing, the men jumped into the boiling surf in equal numbers on each side of the boat. As each breaker advanced and lifted the boat, the sailors in unison pushed the boat forward in the swell and foam. A few such pushes and the boat was safely off the bar into the channel and the crew jumping in again pulled manfully for the shore. On arriving the spectators rushed to congratulate and welcome us. They knew the peril we had come through and said they

had given us up for lost. They had seen boats so stuck on that bar before, but every time the boat had been overturned with consequent loss of life.

That the statement concerning the peril of that bar was no exaggeration was soon to be proved to me. Some months after this exciting incident, my fellow passenger in that boat had occasion to visit Buenos Aires. On his return from the Capital, he was accompanied by Mr. Lewis Jones. Strangely enough they also ventured to make for the River in the boat and their boat also got stuck on the bar and this time overturned keel upwards in the breakers. The crew could not swim but fortunately, Mr. Lewis Jones was a strong swimmer and was able to save himself and the crew. The boat was righted and brought into the channel. The fellow passenger – a Mr. Elaig Powel – was seen holding to an oar with both hands and floating towards the beach. Mr. Jones shouted to him to hold on to the oar and that he was nearing the beach. Having seen the crew safely into the boat, Mr. Jones swam to his friend whom he saw lying on the beach motionless. He was dead!

Mr. Jones himself was on the point of dropping his exertions to save the crew had drained his strength. The blow to find his friend dead was heavy. It was also a blow to the Colony, for Mr. Powel was a scholar of no mean culture and was coming to initiate a scheme of higher education in the Colony. The Colony suffered a great loss in his death.

Such instances occurring too frequently, it is no wonder that the port of Chubut got a bad reputation that freights went high and visits became infrequent. Again, the difficulty was not only with incoming ships, it soon became evident that it was even more awkward for

outgoing vessels. These had to wait, sometimes for weeks before they could get out. Tide and wind had to be favorable because of the bar. A passenger who had waited for some weeks for an opportunity to go to Chubut from Buenos Aires remarked, "If Chubut were heaven, it would not be more difficult to get to it." "Conversely, if that Minister of Emigration were in Chubut now" said that person, "he would say that if Chubut were the *other place*, it would not be more difficult to get out of it."

With nothing to export and no money to buy, there was no inducement to traders to visit the Settlement. Sailors, getting to know the dangerous nature of the bar, were not anxious to risk a voyage. Most of the ships that had sailed into the River had been subsidized by the Government to convey animals, implements and provisions. And they were getting tired of supplying these subsidies. They expected the Colony would have become self-supporting long ago. As a result of the visit of H.M.S. Citon, the Government of the Republic had been galvanized to some spasmodic efforts. But the officials were incapable of grasping the peculiar difficulties confronting the Colonists. This ignorance led them to regard the Settlers, as one Jack in Office expressed it "a colony of mendicants."

In June 1869 after much pleading in Buenos Aires, a shipload of supplies arrived in Chubut with the warning that it was the last subsidy to be expected from the government. The last ship to visit the Colony prior to this one had arrived in May, 1868. The Colony had been marooned for thirteen months!

Friends of the Colony were endeavoring to discover a more reliable and satisfactory way of solving this

intricate problem of communication. The coast was rich with guano deposits and seals. The Colony might be a convenient center for the exploration of these sources of wealth. The idea caught on and a company was formed in Wales with the admirable intention of conveying emigrants and supplies to the Colony and bringing in return guano and sealskins to the British market. The first ship of this company sailed from Newport Mon with eleven passengers on board and a quantity of goods and arrived in Port Madryn in May, 1870.

Imagine the joy of the Settlers when the news came of the arrival of a ship in Port Madryn that was in a certain sense their very own. Brought by sympathetic friends in the Old Country for the purpose of carrying on regular trade with the Colony, supplying necessities from the outside world and supplying a regular stream of fresh emigrants. It was a fine new ship of 300 tons, bearing the talismanic name Myfanwy which figures so delightfully in legend and song in the folklore of Wales. The discovery of the key to prosperity in irrigation and the amazing fertility of the clodless soil had reacted on the spirits of the promoters of the enterprise, both in America and Wales with the Myfanwy as the result. The jubilation of the settlement at this unexpected relief and promise of better times was exhilarating. Here one would like to let down the curtain.

After a short stay, the Myfanwy sailed for Montevideo and Paysandú, taking in a cargo of hides for Antwerp. Meanwhile, the new company got into difficulties. Bills were falling due, subscriptions of shareholders were not forthcoming and the profits of the voyage were disappointing. Having reached Europe, the "vultures" swooped down upon the ship, seized it and

sold it again for a song. Chief among the promoters whose name footed the bills was the father of the Colony, Professor Michael D. Jones, who was sold out of house and home to pay the deficit. Thus, while the Colonists were jubilant because the spirit of enterprise had taken possession of the promoters in Wales and the U.S.A. and were congratulating themselves that the era of isolation was ended and a new era of regular communication had begun…Lo, the door to the outer world was again slammed in their faces!

The "Myfanwy" passed out of view on the eve of that great tragedy, the Franco-Prussian War. That terrible carnage was carried on and had ceased and the Peace of Versailles ratified ere another ship touched the Colony. The momentous events which convulsed Europe and deflected the course of human history remained unknown to the settlement till all was over and peace reigned in Europe once more.

Month after month passed by and suspense gave way to wonder and wonder to alarm. Fortunately bread was not scarce nor the usual productions of the farm. But man does not live on bread alone, and what had become of the great world outside?

An attempt was made to break through the enclosing circle from within. Indian guides were secured to take a volunteer party of six along the north-west route to Rio Negro. Leaving the River at right angles some 50 miles up the Valley, they ascended the high tableland to the North. Here they started on the long travesia of the Hirlam Fyrnig strip; over 50 miles long of dry, barren and waterless pampa. One little refreshing well was discovered on the long dreary track which drips into the hollow called Kytolig where there is a large salina.

Here the road branches. A track due north leads to Rio Negro, another due west leads to the foothills of the Andes. Here our travelers got the first glimpse of the foothills of the Cardilleras which they named Banau Beiddo.

The track for Rio Negro lay north of Kytolig and leading over the dry barren camp of Valcheta. Here the Indian guides pronounced the journey to Rio Negro impossible over the burning Valcheta in that exceptionally dry season, for it was mid summer. There was no persuading the Indians to venture it. So after a little rest at Kytolig and the adding of a little game to the larder, they followed the Indians through the gap they saw before them in Banau Beiddio. The path through this gap was exceedingly rough, running along and across stony ravines. Beyond it the land opened out and promised considerable improvement. As the Indians effectively vetoed the Rio Negro venture, the setters decided to go no farther west, and bidding farewell to their kind guides, returned along the way they had come back to Chubut. They managed to retrace the trail better than they had feared but their return was a surprise to the Colonists in their forlorn condition in the settlement.

After a brief respite in the valley, this same party, with admirable courage, resolved to make another attempt to reach Rio Negro, this time by following the coast. Knowing that there was no fresh water on the route, they constructed a rude apparatus to distill seawater. To distill a sufficient quantity for themselves and the horses proved a greater problem than they had anticipated. In a few days the apparatus gave way under the strain, and after considerable suffering, they just managed to return to Port Madryn.

The state of things in the Colony was becoming serious and increasingly trying for isolation was worsening into durance vile. Truly the trials of the Settlers in those early years were great. No sooner had they surmounted one difficulty than they found themselves confronted with another, a pattern which recurred with such frequency and in such variety as to depress and baffle the most optimistic among them. None but resolute men—and women too, for they were equally brave—could endure and overcome as they did. After the discovery of the key to success in agriculture and the proof of the marvelous fertility of the soil, the early cry to abandon the valley was never once heard again. With magnificent hardihood they grimly determined to make the settlement a grand success.

Chapter 10

John Bull to the Rescue

While the Colonists were endeavoring to break through the vicious circle from within, British citizens in Buenos Aires were seeking to break through from the outside. During the early part of 1871, the Argentine Government had its hands full. There was rebellion in the province of Entre Rios in the north and an Indian attack on Bahia Blanca in the south. The Dailies in the capital drew attention to the jeopardy of the Welsh Colony in Chubut. Bahia is only some 300 miles north of Chubut, an insignificant distance to the well mounted Indians of the pampas on the warpath, provided the season is favorable.

The British Press suggested the dispatching of one of H.M.S. on the South American station to visit the Chubut Colony. Observing this anxiety for British subjects, the Ambassador brought the matter before Earl Granville, the Foreign Minister at the time. He mentioned that the last subsidy from the Argentine Government arrived in Chubut in June 1869 and that this Government refused to send further assistance or to make inquiries in view of the depredations of the Indians in Bahia Blanca. Under these circumstances the Ambassador requested that a British gunboat might be sent to Port Madryn to make inquiries and report.

The intervention of the British Minister, Mr. H.G. MacDonnell, was successful and Captain Bedingfield in charge of the Naval Station at Montevideo sent the gunboat *Cracker* with Captain Denniston to Port Madryn to make inquires. The report of Captain

Denniston is an interesting document and was published in London by the British Government. He found the Colonists in excellent health and spirits which he deemed marvelous considering they had been left without communication with the outer world for twenty months, excepting the visit of the "Myfanwy" in May 1870.

It was pathetic, he said, to witness their gratitude for the interest exhibited on their behalf by the British Ambassador in Buenos Aires. Captain Denniston generously supplied the Colony with provisions and other necessities. He saw nearly every person and heard but one complaint – the lack of communication with the outside world. No wish to leave the Colony was expressed; all agreed they would be satisfied if contact with the civilized world could be maintained with less intermission. No fear of the Indians, with whom they continued on excellent terms, was entertained. The ship's doctor made the remarkable statement that he saw personally nearly everyone in the Settlement and could certify to the wonderful health of the whole community, especially the children. The change from the climate of Wales to the milder and drier one of Chubut had benefited all.

This visit of the *Cracker* left an indelible impression upon the Colony. It was an Angel of Mercy. The officers and men showed such consideration and generosity, such tender solicitude for them in their plight and such patient investigation into their circumstances that the hearts of all were deeply touched. They won the admiration and the affection of the Settlement. It was also an exhibition of the sterling character of John Bull. They had been granted an experience of that humanity of the British character, so

conspicuous in its watchfulness over the movements, enterprises and wanderings of British subjects.

In her recent Day of Adversity, Britain saw British youth, from her own and alien colonies fly to her help from all points of the compass. Not the least among them was the Welsh Colony on the banks of Chubut, under the Argentine Flag, for it also gave of its gold and its sons, to fight and die for the Land of their parents – Hen Wlad fy nhadau – in its hour of stress and peril.

When H.M.S. *Cracker* steamed out of the bay—to be known henceforth as Cracker Bay – to the east of Port Madryn, it had on board the leader Lewis Jones on a mission to induce the Argentine Government to establish regular means of communication with the Colony. He found the fates very unpropitious on this occasion. The yellow fever raged in the city and he was put in quarantine for many days. When able to approach the Government, it was only to fall foul of that tantalizing series of interminable mañanas (tomorrows) so characteristic of Argentine bureaucracy. Mr. Jones records that he paid more than eighty visits to various government offices on this errand. It was due to this persistence that he eventually got the ear of that excellent President Sarmiento. However, the audience was a disappointment and the matter was dismissed with a curt note to the effect that the President had resolved not to grant another dollar to the Welsh Colony unless the Colonists consented to be removed from Chubut to some other place within the Republic.

There was a time when the Settlers clamored to be removed, but the Government then had used every power of persuasion to induce them to stay on in Chubut and kept sending subsidy after subsidy of

necessities with the request. Try, try and try again. Now when the key to success has been discovered and high hopes entertained of a prosperous future, the Government turned round and cried for removal, refusing to help unless the Settlers complied. This time, however, the Settlers simply would not comply.

The Argentine Government having banged the door in his face, Mr. Jones bethought him of the spirit that had been responsible for the providential visit of the *Cracker*. He thereupon visited the British minister for a consultation. This minister rather deprecated interference at this delicate juncture, but promised to consider the matter and see what could be done. Not many days after, Mr. L. Jones received a note stating that the desirability of further assisting the settlement at Chubut had been reconsidered by the Argentine Government and it was resolved to grant three thousand dollars towards the purchase of a ship to enable to the Colony to secure better contact with the outside world.

This welcome change of fortune enabled Mr. Lewis Jones to secure a ship of 200 tons to which was given the auspicious name of Chubut. This ship, well laden with a mixed cargo and with Mr. L. Jones on board, soon set sail for the Colony. Having no prospect of a return cargo, it was freighted by a commercial house in Buenos Aires to load guano, obtained in abundance on the seashore south of the estuary of the River Chubut. This well-meant provision proved a bad speculation. A cargo of guano was taken back to Montevideo. But in the meantime, the "Commercial House" had become bankrupt with the result that the ship reverted to the possession of the Government. No doubt a blunder was committed in having any dealings with that "House". The government was led to conclude that was a breach

of trust, that their gift had been misappropriated for private ends, and for that reason regained possession of the ship.

As compensation for this serious misfortune, a curious accident happened at that time. Another ship belonging to that same "Commercial House" engaged in the guano business was driven onto that fateful bar in the estuary of Chubut. It became a total wreck and taking fire, was burnt to the water's edge. Besides saving many useful articles, the Colonists rescued a number of pigs of celebrated English breed from being roasted alive. These supplied the splendid breed of pigs now to be found on practically every homestead in the settlement. The first pigs, brought so easily from Post Madryn by a party of women to the Valley, had been killed and cured when the Colony broke up in 1867 with the intention of leaving Chubut to go settle elsewhere.

In these early years the increase in cattle was very great, enabling the Settlers to produce more butter and cheese than was required for consumption among themselves. There was also some surplus wheat, which was milled and sold to the Indians, as bread or flour, in exchange for ostrich feathers, furs, rugs and lassos. The Indians had developed a great liking for bread, which the Welsh women had taught the Indian women to make, an accomplishment of which they were very proud. It was the boast of the Indians, indeed that they had learned two valuable lessons from the Galenses, viz: To make bread and to rest on the Lord's Day. They ceased to travel or to go hunting on Sunday and greatly appreciated the Day of Rest.

Increased production supplemented by Indian goods obtained by the truck system, was creating a promising

export trade. Besides, friends visiting Buenos Aires took with them dairy produce, which was in great demand. Ships arrived more frequently bringing merchandise to truck for what they could get. This year of 1872 was brighter than its predecessors. Adding the brighter prospect of harvest, the Colonists were congratulating themselves on being fairly well out of difficulties that had so long beset them and obsessed their spirits. They were never in better health, never in better spirits. Letters were written to friends in Wales informing them of the radical change in their fortune, and painting the rosy dawn of a brighter day. They urged friends to sell up and emigrate to share with them in the coming prosperity of the Chubut Colony.

On the crest of this wave the Rev. Abraham Matthews decided to visit Wales. He was anxious to report verbally to the promoters on the discovery of the secret of recent success and the magnificent prospects. He also wanted to urge the drafting of strong contingents of suitable emigrants at regular intervals.

Welsh, English and Spanish were taught in the
"English Intermediate School" Gaiman

The Director of the English Intermediate School in
Gaiman (1975), Luned Roberts Gonzalez, sits at the
desk donated by British Statesman, Sir David Lloyd
George.

Chapter 11

Reinforcements

The exceptional harvest of 1873 revolutionized the Settlement. Irrigation had made the colonization of Patagonia a potential fact. The patriotic zeal of the days of the start of the enterprise rekindled, both in Wales and in the U.S.A. The Rev. Abraham Matthews held meetings in both countries, stirring up the fires of nationalism and urging emigration to Chubut on a large scale. His rallying cry was "Come and possess this fine inheritance for yourselves and your children. Every family gets a free homestead in a free country and in the healthiest climate." Others helped in the propaganda, notably the fervid Missouri man "Edwin Roberts" and a Rev. D.S. Davies. This campaign was under the direction of the Founder, the Rev. Professor Michael D. Jones.

The interest taken in the Welsh Colony of Chubut by the Welsh people in the U.S.A. was remarkable. An organization formed in 1872–4 dispatched three ships in succession with valuable cargoes and numerous emigrants on board. The three came to grief.

Early in 1872 the "Rush" with 29 emigrants on board reached Buenos Aires. Troubles and disappointments overtaking them, they became disaffected, and encountering a terrific gale on the way to Chubut, they constrained the captain to reverse the direction of the

ship and sail for Montevideo. Here they disembarked and dispersed.

A bolder attempt was made somewhat later when the "Electric Spark" was fitted up. A mixed cargo, chiefly agricultural implements was shipped and a good number of emigrants well equipped for a good start in the Colony, when opposite the coast of Brazil, the "Electric Spark" ran on to a sandbank where it got imbedded, becoming a total wreck. All lives were saved, but the valuable cargo was lost. The inhabitants showed them no little kindness and by various ways and means they were conveyed to Rio Janeiro. Here John Bull, with his usual generosity, came to their assistance and got them conveyed to Buenos Aires and from here they were taken by the Argentine Government to Chubut. Captain Rogers, who navigated the "Electric Spark" on being twitted with bad seamanship, said that when making his "calculations" he had to rely on the watch of a passenger, as the ship had been sent to sea without a chronometre!

On his return to the United States, Captain Rogers gave a glowing report of the prosperity and prospects of the settlement, and a third venture was undertaken. The ship "Luzerne" was purchased and dispatched from the U.S.A. with emigrants and cargo for Chubut. The voyage was longer this time and the provisions ran short. The passengers were in a state of semi-starvation when the anchor was dropped near the mouth of the River Chubut. The immigrants were safely landed and soon were loud in their praise of the excellent fare provided – especially the bread.

So far, the Fates had been more propitious to the Luzerne than to either the Rush or the Electric Spark. It was the intention of the organization in the United States that had fitted up and dispatched these vessels to the Welsh Colony that they should remain for the benefit of the Colony, for the purposes of trade. The Rush, after two or three voyages between Buenos Aires, Montevideo and Chubut, got into financial difficulties and was then seized and stationed for a lightship on the River Plate. The Electric Spark remained in its soft bed on the Brazilian coast. What, it may be asked, lies in store for the Luzerne? Better things were hoped of her. But soon after her arrival a dispute arose, quite a trifling affair, which ended in her being sold at the neighboring port of Rio Negro! These shipping reverses sorely tried the Colony and their friends in Wales and the United States and they showed how difficult a task it was to plant a civilized community in so inaccessible a spot.

Concurrent with the enthusiasm in the United States was an even stronger wave in Wales. When the shipwrecked passengers of the Electric Spark were brought to Buenos Aires they found about fifty immigrants there just arrived from Wales. The Argentine had shown exceptional consideration for these Welsh immigrants. There was a "Home" provided for immigrants on landing in which maintenance and lodgings were granted by the Government, until the ultimate destination of the immigrant was selected. But another commodious house was rented especially for the use of the Welsh, and here they were most hospitably maintained till they could be conveyed to Chubut. This consideration of the Government in keeping them apart from the promiscuous omnium-gatherum of the Emigration Home was greatly appreciated.

The presence of so many immigrants waiting some months for an opportunity to proceed to Chubut awakened no little interest in the city. Commercial houses were particularly interested. The fine specimen of wheat now arriving from Chubut to the market of the Metropolis awakened much curiosity. It was superior to any wheat grown in the Republic. A ship that had brought wheat from Chubut was returning with as many immigrants as she could carry, after long detention. Bachelors and married men with least "encumbrance" were selected for the first batch, as the ship could not take the whole number. The first party would prepare shelters and help in the preparations for the next harvest. An admirable arrangement, as labor was badly needed in the Colony.

This reinforcement arrived August 2, 1874 and at once fell to work along with and under the direction of the earlier Settlers. This foresight assured a splendid harvest. The remaining immigrants arrived in September. Among these newcomers was the Rev. Abraham Matthews returning to his family and congregation on the banks of Chubut.

This year, 1874, the population of the settlement was thus suddenly doubled. The influx brought a serious strain on the slender food resources, but the extra hands ensured abundant crops, so that matters materially improved in the opening months of 1875. The experiences of the old Settlers stood the new Settlers in good stead. The Yankee compatriots also were accorded warm welcome and proved to be energetic and successful farmers. Their new experiences and ideas, acquired in the United States, their self-assurance and good opinions of themselves were refreshing and helpful. Both Yankee and Briton were easily and

quickly fused into a harmonious community. Agriculture was no longer a problem, neither did the sterile aspect of the soil and forbidding look of the landscape discourage labor. Domestic animals were fairly numerous and cheap. Priceless and above these substantial aids and advantages was the amicable disposition of the Indians, which was due to the consistently kind yet firm treatment they had received from the Settlers during nine years.

The ecstasy that possessed the early Colonists at the expiration of what some had come to regard as a time of hard transportation, was very touching. Handling once more the "Old Country" money, wearing new "Old Country" garments. Weeping, laughing, talking with fresh faces and in the grand old language of dear Wales – it was real luxury! Groups could suddenly be formed exchanging inquires and reminiscences about places and people, about friends and acquaintances and in low whispers of the dear old folks at home.

Leaving Wales in times of prosperity, these newcomers were better equipped in every way than were the first Settlers. When the Settlers of 1865 left Wales, it was passing through bad times industrially and the first Settlers were in consequence poor and received free passage on signing to pay when they were able. This was considered unfortunate at the time, but subsequent events showed it to be a fortunate circumstance that the Colony was not born with a silver spoon in its mouth. No band of men would have endured the privations of these early years had they not already felt the hard pinch in Wales and were now with no resources in reserve to fall back upon. Having nothing to loose, but everything to gain, they drew upon their energies and mother wit and let it be said on their imagination with

grim deliberation to stick to it until they had successfully solved the Sphinx's problems – "How to colonize Patagonia."

The immigrants of 1874-5 brought fresh supplies of energy, intelligence and idealism to assist the promising evolution of the Colony. Among them were leading agriculturists, public men and leaders in the industrial districts. Conspicuous among them were three trained and accredited ministers of the Free Churches and a ministerial student just out of Bala College. These had resigned pastorates at home in order to come and shepherd new flocks and share with them the lot and vicissitudes of colonial and frontier life.

These ministers were Revs. David Lloyd Jones, John Caerenig Evans, and D.S. Davies. The first two soon settled as Pastors of Congregational churches and remained faithful at their posts till death took them after long years of indefatigable and splendid service. Rev. D.S. Davies returned after a brief stay to a pastorate in Wales.

The excellent harvest of 1874 laid emphasis on the crusade of Revs. Matthews and Davies and also the fervid pioneer Edwin Roberts. Letters also wrote home giving glowing accounts with the result that the stream of emigrants grew stronger. The Argentine Government helped, and the Lamport and Holt Line agreed to take batches to Buenos Aires, whence the Government took them to Chubut. The Government also granted free passages from Liverpool to necessitous emigrants. The good times of the early seventies getting to an end in the coal mining districts, the slack times and free passages combined to swell the

tide, so that towards the end of 1875 some 500 fresh immigrants had been poured into the Colony.

It was now becoming evident, as the River was not rising as it should do, that there would be a failure of harvest in 1876. Also the reckless exportation of wheat was making the matter of food critical. Farmers had been too eager to sell and merchants, multiplying in number vied with each other in buying up and shipping away all the grain out of the Colony until it suddenly dawned upon them that they were on the verge of famine. Once more an appeal for help was nobly responded to by the Government. A salutary lesson was now administered to the Colonists when they found themselves under necessity to import grain for food and seed and to pay for very poor quality three times the amount received a few months previous for the finest wheat put on the Argentine market. More farms were measured on both sides of the river and allotted to the fresh immigrants. The site for a second town was selected some 20 miles due west of Rawson, to which was given the Indian name Gaiman. Two fresh Settlers, Rev J.C. Evans and Mr. D.D. Roberts having selected farms in the neighborhood, decided to build and reside here. Around these two intrepid pioneers there soon clustered a number of houses and the spot became a most progressive centre of the Colony.

The new arrivals wisely decided to go on their homesteads as speedily as possible. Temporary dwellings of adobe were run up, which in the warm, dry atmosphere quickly became habitable. The housing problem did not present much difficulty owing to the mild climate and the rare occurrence of rain. To sleep in the open air with a rug under and a blanket over you was no hardship. Johnny Newcome however is shy and

afraid. The merchants helped matters by throwing warehouses open for shelters as parties arrived. This considerably minimized the discomforts. But the difficulty of preparing food was hardly borne by persons who had always sat at tables for regular meals. So greatly was this felt that at times one feared a repetition of the Mud Settlement disaffection. At this time the situation was relieved by a pervading sense of good humor such as is experienced by parties camping out or picnicking under difficulties.

Here is an instance. One exclaimed, "Lads, I am starving so I am going to the stores for something to eat." He returned with a pound of rice. He asked the women how to cook it and was told to put a saucepan half-full of water on the fire and when the water boiled to put rice in and keep it boiling until the rice was soft. He did so, pouring the whole pound of rice into the saucepan. A woman, seeing what he had done, took a cupful out, remarking that he had put too much rice in. "Not a bit too much, you don't know how hungry I am" said the man, standing guard over the saucepan after this. The women were much amused when presently they saw the man getting increasingly busy turning back the swollen grains in the act of rolling over the edge of the saucepan. They greatly enjoyed his growing perplexity as the rice in increasing quantities kept rolling over the whole rim into the fire. At last, in desperation, he flung the spoon on the table exclaiming, "This land is under a curse, if by luck one manages to find a bit of food, he cannot keep it in the pot to be cooked."

SECOND PART

The Colony of Chubut Valley in the Last Part of the 19th Century

In 1905 the Colony paid homage to Rev. David Lloyd Jones

FIFTEEN YEARS IN PATAGONIA

(Extracts from talks given in chapels of Wales)

Chapter 12

The Soul and Brains of the Colony

"Now, I am myself part of it" W.C. Rhys

The real soul of the Welsh Colony of the Valley of the Chupat River was a professor of the University of Bala, Michael D. Jones. After a visit that he made to the colonies in the United States of America, where he was able to evaluate the effects and results of the environment on the culture and religion of the Welsh Settlers there, he decided that there was a need to determine first what type of colonization was to be applied, the size of the land allotted, and the degree of isolation required, to be able to develop the ideal of his dreams.

Convinced of the enormity of this evil phase on some of the emigrations to America, our patriot initiated a movement with the object of obtaining a large tract of land with the privilege of introducing exclusively into it his own nation.

But this project had a still grander aim. Our patriot was a radical--as every true Celt tends to be. He was no believer in the divine right of kings, but a firm believer in the divine right of man. He believed in the nobility of man and in the nobility of labor. He was an enthusiastic believer in the thrift, the endurance, and the mother wit of the toiling masses. His wish was to plant them on the land in the character of freeholders. In the Grand Old Book he read of the time of plenty and splendid prosperity in store for the children of men who are now exiled from their God-given land by the tyranny of Nimrodic spawn.

There are three kinds of colonies:

First Kind: Some colonies are merely money-making speculations of adventurers. Men enter into contract with the government to settle so many people on so many leagues of land. The easiest possible terms are secured from the government and part of the concession is divided into small allotments, which are sold to Settlers at as high a price as can be obtained. The remaining part of the concession is reserved till the Colony shall have won a good name and fair prospects. Settlers are assisted; food, animals, implements, seeds, fences, etc., being supplied on credit. This kind of Colony is generally ruinous to poor Settlers, who, sanguine of success, are too easily induced to speculate and draw upon themselves the crushing weight of debt. Under this burden, after struggling through a few seasons, and other misfortunes incident to the best colonies in their embryonic state, they succumb and are crushed. The allotment, stock, and improvements, revert to the former owner. Of this kind are settlements belonging to the railway companies. Beware of this class of Colony, unless you have money enough to meet

Greek as Greek. Money is the only thing they respect, and the only thing they fear.

Another Kind: Those colonies settled directly by the government. People are induced to settle by a liberal grant of land, and a wise and limited assistance to start. The progress of such colonies is slower and less showy at the beginning, but is less disastrous to Settlers who have no capital, and they are the most flourishing in the long run. The drawback of these colonies is that they are generally located in districts remote from conveniences of markets, etc. Speculators have a subtle influence over the government, and always adroitly manage to get the best slices of the land for their own concessions.

The Third Kind: Those colonies formed by philanthropists by means of whom they seek to establish a community in accordance with some favorite idea and thus produce, from a certain point of view, a model society. These men obtain a concession of land and settle it with those immigrants for whom they have specially procured it. Some of these colonies are successful, and some are not; and in case of non-success, the philanthropists themselves are the worst off. Moreover, should they succeed, these well-intentioned founders and heroes -- dreamers perhaps you will call them -- receive for their reward more applause than profit and more glory than gain. Usually, however, even this is withheld, until they have ceased to be on earth.

Of this class are those cooperative colonies established of late, with good promise of success in various places. You will perceive that the Colony, upon the ups and downs, of whom I propose to give you a glimpse,

belongs to this class, and has peculiar and distinctive features of its own.

As to the man responsible for the creation of the Welsh Colony, the late Professor Michael D. Jones, whatever may be the future of the Colony, it may be said that no movement was inaugurated with purer motives, with higher ideals, and with nobler and altruistic purpose, than that of settling the Chupat Colony. He was a little-understood philanthropist, father and founder of a dream that cost him not a small fortune.

Forty-two years have passed, yet there are some living today, who well remember with what strange feelings they watched that stately ship, the Mimosa, weighing anchor on the Mersey, to leave the shores of Britain with its freight of 153 souls. It was in the month of May; they thought of the Mayflower. Would history repeat itself? After a trying voyage of nine weeks duration, the ship entered the calm of the fine bay, Golfo Nuevo, which the accurate Fitzroy had carefully surveyed many years previous. The anchor was dropped in what is now Port Madryn, named after Madryn in North Wales. The men, women, and children feasted their eyes on the barren heights surrounding the bay. If it is true that the airy castles began to crumble ominously at the sight of such sterility, it is equally true that sight of land, and the prospect of treading again on *terra firma,* after the long spell of "cradling on the mighty deep" was most refreshing. The boat soon touched the beach and everyone leaped ashore. It was amusing to witness the variety of ways the emotions in each individual would manifest itself. One strong fine looking man stooped, and taking up a stone, kissed it almost in a delirium of delight, and shrieked, "Land!"

Port Madryn, however, was not the ultimate destination, but the River Chupat. And between them lay a sterile, waterless track of land some 45 miles wide. Oversea to the mouth of the river was a much shorter distance. So after a few days rest it was decided that the men should go overland, and the women and the children overseas to the mouth of the river. It is not the evil we fear that always overtakes us, but generally that which we never dreamed of. No one imagined that the crossing of 45 miles of desert between Port Madryn and the Chupat River would prove such a task as it did. Greater hardships and perils were experienced on this short land journey than during the long and dreary voyage of 8,000 miles across the stormy main. So serious was this short journey that the lives of the Settlers were in great jeopardy.

One by one, men reached the Valley, having all suffered more or less. One was lost in the bush, and his skeleton was found some years later by the Indians in a sitting posture by a bush. The Indians who found him, brought his pocketbook to the Colony.

The women and the children fared perhaps even worse than the men. Taken in a small sloop for the mouth of River Chubut, they were overtaken in a storm that drove them out to sea, so far that it took 17 days ere they were able to reach the river, and their suffering for want of food and water was very severe. All arrived safely in the end on the banks of the Chupat, where doubtless some of their offspring will be found when the *trumpet shall sound* on the *last day*.

Here then, we have followed this batch of one hundred and fifty three Welshmen to their new home, where

they wakened for the first time, the solitude of the vast Patagonian wilderness with the sweet strains of the grand old language of Britain. Their nearest civilized community was some two hundred miles away, reachable only over wild waves or through wilder territory of Indians. *Some cannibals*! They had erroneously been told in Wales. But soon the Indian would become the great friend and helper of the *"Galenso"*.

ADDENDUM

NINNAU, the North American Welsh Newspaper, on October 1, 2002, published the article reproduced here. We thank the Editor, the Author, and the Photographer for giving their authorization.

Michael D. Jones: People's Man, Patriot, Prophet
By Cathrin Williams

He has been called the *Greatest Welshman since Owen Glyndwr, The Foremost Welshman of the Nineteenth Century,* and *The Father of the Welsh Colony in Patagonia.* Yet today, in Wales, few are aware of the debt we owe to this man of the people. He lived before the founding of the Welsh National Party, and yet could be called its initiator.

Born in Llanuwchllun, North Wales, to the minister of the Independent Chapel there, Michael D. Jones studied Theology and eventually followed in his father's footsteps as Principal of the Theological College in Bala. However, his first ministry was outside of Wales, on the other side of the Atlantic. His sister had already left Wales for the United States, and in 1848 Michael

D. Jones followed her and was ordained minister of a church in Cincinnati.

His ministry there was to have a profound effect on his life and the lives of many Welshmen. There he became aware of the fate of those who emigrated from Wales, and saw at first hand how soon they became assimilated, thus losing their language and customs. He realized the inevitability of such assimilation when the new emigrants were a small part of a much stronger majority.

The outcome was the idea of founding a new Wales far from outside influences, and so was born the idea of a Welsh Colony in Patagonia, South America. Michael D. Jones, with others, promoted the Colony to such an extent that in 1865 his dream became a reality and 160 Welshmen and Welshwomen sailed to Argentina. Thus was born Y Wladfa, the Welsh Colony, which up to this day reveres the name of one of its founders.

However, although visiting Patagonia in 1882, Michael D. Jones's future lay in his native Wales where he devoted his life to the country, its religion and its language, and it was his two sons who emigrated to Patagonia. One of his sons, Llwyd ap Iwan, married the daughter of another founding father, Lewis Jones, and their descendants still live in Chubut.

180 years have gone by since the birth of Michael D. Jones in the chapel house in Llanuwchllun. Many have visited the house without realizing that here was born one of the greatest Welshmen of all times. In July this year a commemorative slate was unveiled and a service held in the chapel under the auspices of the Wales-Argentina Society.

This society was established in 1939 in order to promote the links between our two countries, and is a source of information to those from Wales who visit Argentina or who wish to know more of the Welsh Colony. At the same time it promotes the visits of many from Y Wladfa who come to Wales to learn Welsh. In keeping with the ideas of Michael D. Jones, who was above all a Christian, the society also sends out ministers so that those who speak Welsh, and there are many, can worship in their native language.

It was one of these ministers, and a past Chairman of the Society, Rev. Eirian Wyn Lewis, who gave the address at the meeting in the Old Chapel of Llanuwchllun on July 27, 2002. He stressed the importance of Michael D. Jones to Wales and Patagonia, and at the same time paid tribute to his wife. It is known that it was Mrs. Jones that funded much of the venture, impoverishing herself and her husband in order to fulfill his dream.

Following the service in the chapel, the slate* was unveiled by Mrs. Eluned Bere, the great-granddaughter of the Rev. and Mrs. Michael D. Jones, one who was herself brought up in Bala. Dr. Arturo Roberts, of New Jersey, a great-grandson, who was brought up in Patagonia, then spoke of Michael D. Jones from a more personal point of view. He also spoke of his plans for Bodiwan, the house in which Michael D. Jones lived as Principal of the Theological College. This house, purchased by Dr. Roberts, is to become a museum of Y Wladfa, the Welsh Colony in Patagonia, and its founder, Michael D. Jones. Then, and only then, will this great Welshman have a fitting memorial in his native Wales.

*The plaque reads, in translation: "In this house was born MICHAEL D. JONES, People's Man, Patriot, Prophet. Principal Founder of the Welsh Colony in Patagonia."

Two Great-Grandchildren of Rev Jones: Dr. Arturo Roberts and Mrs. Eluned Bere, in front of the house of M.D. Jones.

House where the Rev. Michael D. Jones was born, in Llanuwchllun, Wales

Chapter 13

The Friendly Indians

Soon after my arrival in the Colony, I rode up country in the company of one of my church members. We met an Indian tribe and some of the men came to my friend and shook hands heartily. They asked whether I was a Christian. I was about to affirm, but a quick kick on my shin closed my mouth, while my companion replied, "No, he is a Galenso" (a colloquial word for Welsh). A cordial shake of the hand was the sequel. In these days, as in those of the Apostles, the name of Christian is blasphemed among the heathen on account of the unworthy characters of many that bear it.

This friendliness of the Indians was our best defense against attack. The tribes that knew us passed our character on to those who knew us not, and those nearest were a wall of defense against the more remote. We suffered several serious scares. On one occasion a special messenger arrived from Chickitchan, an Indian chief, notifying us that a warlike tribe -- a terror to some Spanish Colonists -- had asked him to join them in an expedition to destroy our Colony, for the sake of plunder. "I have replied" said brave old Juan, "that ere they attack the Welsh, they must first fight my tribe, for only over our bodies shall they march to Chupat. But lest they go South, and avoid passing through my territory, be on your guard on the next full moon." There was considerable excitement in the Colony on receipt of this warning, and every preparation was made to give the invaders a "warm" reception. But God's shield was over us.

A farmer had barricaded every window in his house, except one small one, but against this he had piled up all the tin cans that he could lay hands on. In the dead of night, he was awakened by a tremendous noise; he gave a shout that terrified all in the house, and proceeded, revolver in hand, to search. Through the little window, actually something had pushed its body, knocking the whole pile of tins down...What?...*a cat!* Thus began and ended the Indian invasion that threw the Colony into dismay for two or three weeks.

Some years ago, under the pretext of clearing the back country for colonization, a raid was made upon these poor inoffensive children of nature, and many a tribe was wiped out of existence. Many were killed and the remainder, deported over sea. Men to the sugar plantations of Tucuman, and women and children to towns or cities. Those were terrible days for the Colony, for our sympathies were with the Indians. Some of the bravest fought to the last, preferring death to captivity. Among these was a son of a chief well beloved by the Welsh. He was of fine physique, over six feet in height, a total abstainer from alcohol, having a splendid influence with his tribe. We knew him as *"Y brawd mawr"* (the big brother). Brave and fearless to the last, he fell in battle fighting for his home and people.

It was during this time, when the ruthless soldiery were sweeping the back country, that a party of Welshmen were killed by the Indians. They had gone on an expedition to explore the region of the Andes, and one night an Indian came into their camp, and inquired their business so far up country--for none of the Colonists had been so far before. They explained to him what they were doing. He asked them to come and see the

chief of the tribe in his encampment, which was a distance away. This they promised, but after, they got afraid, and early in the morning they started back to the Colony. They were within two days from the Valley, when a fearful yell was heard behind them, and two of them fell, pierced by lances, the other, a Llanelly man, B. Davies, sold his life dearly. The fourth reached home to tell the horrifying story. Much as we were moved, yet no cry for revenge was raised. The Indians were being hunted down by soldiers, and they had taken this party for spies, their failing to turn up to see the chief, and running away, confirmed the Indians' suspicion. Had they gone as they had promised to see the chief, we fully believe that no harm would have befallen them.

From their Indian friends, the Welsh youth learned much "science of the land". From their experiences searching for stray animals and their hunting expeditions, they learned how to follow a trail unerringly. They were fond of going in groups to hunt the lions (pumas as the natives call it), the guanacos, and the ostriches. The South American lion is smaller and not so fierce as its African cousin, and its hunting, by day, affords fine fun. But sometimes one has to tackle it alone with only one's horse and dogs to help.

"We have no meat for tomorrow, David", said Mrs. Jones to her husband on Saturday. "I'll take the dogs and try for an ostrich" he said. Having ridden some miles into the bush, he saw a flock of ostriches, and set the dogs on them. They brought one to the ground, and he dismounted to dispatch it. He had only just done so when he observed a lion, not far ahead, watching the proceedings. He sent the dogs after it, and he himself followed on horseback. The lion was run down, and by

means of the *bolas*, was killed. David got down to skin the beast, but found that he had left the knife where the ostrich was. He rode there to fetch it, but found that another lion had been there in his absence and taken the ostrich away. This was a bitter disappointment, for the dogs and the horse were too tired for any more exploits that day. He picked up the knife and went to skin the prostrate lion; when he got to it, lo, it was alive! The lion has as many lives as a cat, and David had a hard time, he said, "to kill it the second time". The lions are not very numerous. During my stay I only saw one, and between me and it there lay a deep ravine, a fact that I rather liked, than otherwise.

The Indians that remain are few in number compared with what used to live in the valleys of the Andes. Between those that remain and the Welsh the same old good feeling prevails.

Into Gaiman, a town in the centre of the Colony, an old Indian woman came one day with some onions for sale, and she was discovered to be the sister of an Indian chief who had shown no little kindness to the early Settlers. The Congregational Minister, W.J.C. Evans, invited her to come to tea at his house one day. "How shall I set the table, Mother", said Miss Evans, "must I put on a clean cloth and get out the best china?" "Yes", said the mother, "set it as nicely as if Queen Victoria were coming to tea with us!"

To show how reciprocal this feeling was, let me give you one other story. Some time ago, a Patagonian Indian Chief was dying in one of the hospitals in the city of Buenos Aires, capital of the Argentine Republic. He had gone to the city to see the President on a matter touching his tribe, and was taken ill with fever. Just

before his death, he surprised those attending him in his last moments, saying, "I am going to the heaven of the Galensos (Welsh) for the place where these good people go to, must be a happy place". Thus passed away dear old Francisco, to whose brother, Galetch, and nephew, Hiykel, I myself had the privilege of speaking to them of the Great Spirit and His love to Man.

The Tehuelche Chief Chiquichiano, poses with a son and a grandson of William Casnodyn Rhys (David Ivor and Edgar) 1943

Chapter 14

Agriculture by Irrigation

We will now go back to the farmers, and see what progress is made by them. Agriculture is a very different business in the Colony than it is here in Wales. Things are completely reversed there. Here the earth is green and the heaven--well generally black. There, earth is black and the sky is a beautiful blue. Christmas there is never cold like here, for there it comes in midsummer. The Sun at midday is in the North, and the *Man in the Moon* always stands on his head. Little robin redbreast is not little at all, but as big as a small pigeon. Here the birds sing, but there they are nearly all silent; the toads and frogs sing in their stead. You ought to hear a concert of frogs, you would never forget it, and you would enjoy it. On a fine, calm spring evening, when all the canals and ditches are full of water, the whole atmosphere is tremulous with their noise, and it goes up the gamut from deepest bass to highest treble, and is heard from end to end of the Valley, one vast and perfect harmony, indicating that the inhabitants of the mud are having a lovely time.

At first the land was prepared as in this country, for rain; but no crops were obtained, and the recurring failures reduced the Colony to the verge of starvation. What was to be the final trial, by mutual consent, gave the key of progress. A farmer had sown his share of seed, which was watered by an opportune shower. It gave good promise for a while, but as no more rain fell it began to droop. The farmer one day stood on the margin of the river, which at the time was full, and carried a vast volume of water to the sea. The idea of

irrigating the wheat flashed across his mind. A shallow ditch was soon made that carried sufficient water to cover his little field of wheat. The next morning he found that the wheat had revived, and the farmer knew that he had solved the problem of wheat growing, and that henceforth irrigation was to be the order of the day.

This little patch of wheat with its improvised ditch, became an object lesson. Groups of more or less half a dozen Colonists, would open a ditch in common to some convenient farm, and both ditch and farm would be exploited in common.

But periodical failures of the river to rise into the ditches, showed the need of deeper ones. This, and the need of more extensive cultivation, gave rise to larger combination of farmers, which in the course of time, developed into strong and orderly companies. Each farmer now cultivated his own land, subject to the social exploitation of the water. Land tenure thus became radically modified. Landlords are units in a community, the joint action of which enables them to transform their land into something of practical value. Independent action cannot bring water -- the task is too great -- and land without irrigation is valueless.

These companies transformed the ditches into canals, and with these, uncertain irrigation has given place to a constant supply of water throughout the year, whether the river rises or not.

The water supply is the property of the farmers collectively, and is regulated as best suited to the whole group. The farmers are individually subject to the collective whole. An appointed superintendent sees that everyone gets his fair share of water. Harvest

over, the acreage or tonnage is taxed by a committee of farmers themselves, just sufficient to meet expenses of management and repair, the surplus money being returned annually, *pro rata* to the shareholders.

Irrigation is a laborious though a somewhat interesting process. When the land is tilled and sown it is divided into unequal plots – *squares* -- according to the level of the ground. Into this a stream of water is turned, and it is astonishing the amount of water a little plot will take. I have seen quite a fair stream running for hours into a crevice in a plot. When the plot is covered the water is let off into a lower plot, and so on from plot to plot. Sometimes the bank made around the plot to keep the water in, breaks, and many are the shifts made to close it again, for it must be quickly done, as the water must not be too long on the plot lest the seed burst.

Take an instance; a bank broke where there were three or four men watering together. The breach was mended, but they found that in the meantime the water had soaked all the land around them, so that retreat to dry land was difficult. They must wade through mud. One of the party was rather old and weak. "Come on my back, David," said a young and strong fellow companion. James started with his burden, but soon got stuck. He stooped and used his arms to extricate his legs, but the arms also got stuck, and his human burden, not to send him out of sight in the soil, had to get off and manage as best he could.

A farmer's wife brought her husband's meal where he was superintending the water, and while she was waiting there, the bank broke, the farmer shoveled earth into the breach, but the rushing water washed it away. It grew wider and threatened to let all the water out.

His wife came to his rescue, and spreading her dress across the gap, said, "now through in the soil." This he did, and managed to close the breach. Such a wife is a true helpmate! Sometimes a man will lie full length in a breach while another throws in the soil to fill the gap. Often-times the men strip off their garments to place them in the gaps. No one minds getting wet, for the climate is so delightfully dry and warm, that a bath is refreshing rather than otherwise. Uneven land gives great trouble, and sometimes a farmer has to watch night and day for a week or more. One poor fellow had been at it for a week, and his tender wife hit upon a splendid plan to give him a little rest. She carried a light bed to the plot next to the one under water. Having made it she begged him to let her watch the banks while he took a snooze, promising to wake him on the slightest indication of a breach. Glad for the opportunity and for his good wife's admirable little scheme, he lay down to rest; but scarcely was his head on the pillow, when the bank broke, and the bed was floating like an ambulance canoe!

Irrigation is becoming easier as experience is gained, and the American horse-shovel has brought about stronger banks. The horse-shovel is scarcely known in this country, but is a great boon and an admirable labor-saving contrivance. Briefly, it is a shovel worked by one or two horses, and removes a good barrowful of earth at a time. The man simply guides the horse and shovel much as a plowman does. The horse does all the heavy work such as plowing, harrowing, banking, ditching, reaping, and binding hay.

You must remember that irrigating, with all its discomforts and mishaps, entails far less labor than liming, manuring, and weeding, as in Wales. The land

is only plowed once in the season, and harvest is never in danger of being rotted by the rain. Animals require very little attention or experience. No housing, or penning being necessary, for the climate admits their being in the open, winter and summer alike, and they find their own food. The young calves while sucking are kept in pens, so the cows have to come to the house once or twice a day to suckle their calves, and the housewife sees that the calves don't get all the milk.

Wheat growing is the chief industry of the Colony, and this wheat is of the best quality. In the Exhibition of Paris in 1889 the Argentine Republic was awarded the gold medal for the best wheat in the world. That sample of wheat was from the Welsh Colony, grown on the farm of one who came to Chupat from North Wales. The very thing that does well in the Temperate Zone, does well in Chupat also. But as very little rain falls, irrigation must be applied to all vegetation.

If we summarize the activities due to irrigation we observe the following: The formation of these companies for purposes of irrigation, the drawing up of the statutes, the changing of the works, all without the aid of lawyers or experts have afforded these toilers a splendid training. The amount of capital laid out on canals and dams is amazing. Four canals have been constructed; two are over 25 miles each in length, and the remaining two are a little shorter, about 20 miles each. The cost of each running into several thousand pounds. These large enterprises are comparatively recent and are surprising evolutions of the small beginning referred to. In this manner cooperation firmly established itself in the Colony, and as time went on, and the Colony grew, it was applied to other matters.

Chapter 15

Cooperativism and Activities in the Colony

The storekeepers owned the ships, and the thrashing machines, and the toll for the use of the machines enabled them to keep their little ships going for some months after harvest without being under the necessity of purchasing from the farmers. The farmers were thus reduced to the necessity of selling their wheat for what the storekeepers chose to pay them, which would be scandalous low prices. Cooperation suggested a corrective. "We got our canals", said the farmers, "by sharing the requisite labor; let us get our thrashing machines by sharing the requisite expense." One machine with engine and all requirements costs about 1,000 pounds. Some of the farmers succeeded in buying the machines they required, some of the new ones ordered from Great Britain. The machines already at work in the Colony were purchased at a fair valuation, and where this was not got, they were allowed to rust away as inglorious reminders of a trampled monopoly.

These various cooperative companies have taught the Colony the useful lesson that mutual help is better than external interference, and that combined effort or cooperation is better than capitalism. A most salutary lesson and one the knights of labor are too slow in learning. Combining for resistance of what is deemed unfair, or unjust on the part of the employers, is not what is wanted today. Time has shown that this can be met by the simple process of imitation by the

employers. Strikes and lockouts are disastrous methods of settling disputes. The satisfactory method is cooperation; if you cannot agree with your employer, don't spend thousands of pounds to show that you can live without him; spend them rather to show that you can work without him. Cooperation is capital -- the best capital -- the laborers' own capital.

In Chupat this state of things came about, not as a result of merely reasoning, but from sheer necessity. There were no monied men to do the work. Stress of circumstances forced the Colonists to combine, and finding it succeeding so well in one direction, they applied this sensible socialism in other directions, and found that monopoly fell invariably before cooperation. An excellent *esprit de corps* has thus been engendered and continues to be a marked feature of the Colony. Labor has a dignity and the laborer a status that is not enjoyed in this land. Farm servants find that the favorite method of hiring is that of profit sharing. Thus he shares with the farmer in his weal or woe. This profit sharing is acknowledged to be the fairest and less disastrous plan for both parties, and is becoming much more popular than the old system of yearly wage.

The latest development of cooperation is the fine business carried on under the name of *"The Chubut Mercantile Company"*. This is a properly registered company, with a capital subscribed almost entirely by the farmers. It purchases and sells for the Colonists, and deals in the markets of Buenos Aires and Liverpool, and has a large ocean ship of its own. The manager and all the clerks and servants are Welsh, and so is the directorate of the Company. The staple trade of the Colony is done by this company, and a Welsh Balance Sheet is issued every year. This Cooperative

Firm was started in 1885. Since then the Republic has passed through more than one financial crisis, and one serious revolution, and many companies and business firms came to grief. In 1890, every bank in the City broke, except the London and River Plate Bank. The Welsh Chubut Mercantile Company survived it all without a hitch, without a tremor. Its bills have never been dishonored. I am sorry to hear that the few last years of flood have seriously impaired its position, but let us hope that it is only a transient phase, and that very soon we shall see the Company as vigorous as ever.

Building the Port Madryn branch of "The Chubut Mercantile Company". 1905

Life and property are as safe in the Colony as in Wales. Unfortunately, this is not true in all parts of the Republic, where administration of justice is much too lax, and where criminals too easily escape the clutches of the law. The reason for this difference is that the vast majority of the people are law-abiding Welsh folk.

An incident occurred in 1879 that taught a salutary lesson to the foreign element that comes into the Colony. A Welshman by the name of Aaron Jenkins, was foully murdered by an outlaw native without any provocation whatever. The news went like wildfire through the Colony; it was a busy thrashing season, but all work was suspended and the men turned out to search for the murderer. He had escaped into the bush on horseback. He was tracked for two days. Some Spaniards said, "You will never catch him, he is too well used to the camp, and will dodge all pursuit." But he did not escape. After tracking him for two days through the wilderness, and valley, and river, he was found hid, horse and all, in a clump of pampa grass. Finding he was discovered, he leaped into the saddle, and commenced threatening his pursuers with the *"boleadoras"*. At this, one of the group opened fire and shot him. We would not advocate the practice of lynching, but where the Government is remote and sometimes negligent, Colonists have had to resort to extreme measures of self-defense. This amazed many at the determination and success of the Welsh, and they passed this story to their kith and kin that come into the place. The papers of the Republic, when they heard of the affair, applauded the action of the Welsh and called Chupat a model Colony, showing to other colonies what to do to the unpunished scoundrels that are allowed too easily to escape the deserved punishment.

The Colonists used to be very fond of hunting. Before the herds and flocks had increased very much, hunting kept the larder in meat. There are no game laws in Chupat, and you can take your gun and go for wild guinea-fowls (partridges) or ducks wherever you like, for they are very numerous.

The Welsh have not forgotten the intellectual ways and means of providing wholesome entertainment in distant Chubut. Eistedvods, concerts, Thanksgiving Meetings, Anniversaries and Mass Meetings of the various companies furnish ample opportunities for self-improvement.

The Colony has recently sprung into great publicity, owing to its present troubles. These may be attributed to a remarkable convergence of painful incidents.

Education is very defective. The Education Department of the Republic is very rich but badly administered; especially is this the case in Chupat, remote as it is from the central authority in Buenos Aires. The Colonists have been making up for this deficiency as best they could with schools and masters built and paid for by themselves. The children learn splendid Welsh and would shame many of the *llenorion* of Wales. I have known young children to write a slateful of faultless Welsh dictated to them. You should hear them go through the multiplication table in Welsh, and you would be astonished at the fine elasticity of the *grand old language.* They also learn Spanish.

Again, there was recently a grave prospect of war with Chile, which necessitated a strict enrollment of the National Guard and strict attention to military drill. Young men born in the country are liable to military service. Parents brought up in this Country resent this invasion into the home--it is so unlike what they have been accustomed to. It was all the more galling as the drilling was done on the Sunday. This day in Roman Catholic countries is reckoned the most convenient, as there is thus no interference with the daily occupation.

Another blow came in the form of two successive years of disastrous floods, which caused many buildings to tumble down, and drove the Colonists for safety to the tablelands on either side of the Valley. *"It never rains, but it pours"*. These concurrent evils have driven some into a state of despondency. Add to this the fact that there are many there without land of their own, having gone out under contract to construct the railway. They were promised farms of their own when the railway work was over, and the Government decreed that farms be measured for them, but the contractor stepped in, and claimed the land allotted to them as his, on the ground that he had not brought them out to labor for him. In this way they were done out of their due. These would feel the present distress much more than the farmers.

A generous offer of land by the Canadian Government, and a visit to the Colony of agents for Canada, W.W.J. Rees of this town being one of them, came in a moment when the Colonists were turned out of the Valley to camp on the hills. It is not to be wondered at, that the built-up disaffection found vent, and that many very readily accepted, conditionally, Canada's offer. They are a small proportion of the Colonists, and their exodus will not hinder the progress of the settlement. We wish them well in Canada.

But the evils I have mentioned are passing, and not permanent. Education has to be fought for, even in our own Country. We have a stiff battle confronting us here. We are going to do a bit of fighting tomorrow night at the Albert Hall. It will be righted in the Colony by and by. There the Military Service is what it is in all civilized counties except Great Britain -- and some prophesy we shall have conscription here soon. They

have the same arrangement in the United States as they have in the Argentine Republic, I am told. The Sunday drilling is a detail which doubtless will not be allowed to continue long.

The floods are exceptional; during my fifteen years residence, not one such flood occurred. Some pretend to believe that a permanent change of climate has set in. The Old English Taunt is very true: "When it rains, the Welshman says, 'It will never be fine again' ". In the rocks above the Colony there are evidences of great floods in days gone by. We have seen them, and used to remark that possibly these floods will come again, sweeping all before them. They have come, but the remedy is at hand. The river is extremely tortuous, as its name *Camwy* implies. Let it be straightened, and it will carry many times its present volume to the sea in the same amount of time. I have no doubt this will be done in the near future.

Chapter 16

The Spiritual Legacy of the Colony

Religion in the Colony is of the strong, evangelical type prevalent in Wales. It is divided between the three great denominations. The Free Churches that share Wales between them; that is, Congregationalists, Calvinistic, and Baptists. Between them they have some fifteen regularly constituted churches, and six ordained ministers. These Free Churches, though holding faithfully to their distinctive tenets, work together in perfect harmony and concord. Much greater warmth and union exist between them than in this Country. At an Anniversary -- Cwrdd Mawr -- it is the settled order that the preachers represent the three denominations.

On one day of the year, there is no denominationalism as far as the Free Churches are concerned--this is the Harvest Thanksgiving. It is held on a Monday in April, not on a Sunday, for that involves no sacrifice. The Day of Thanksgiving is a holiday throughout the Colony, when well attended prayer-meetings are held in all the chapels, twice and three times in the day. Not only is work set aside, but denominationalism is set aside also. Everyone is expected to go to the chapel nearest him. Moreover, they don't believe in a thanksgiving that costs them nothing. A collection is taken at every meeting, and as it is an interdenominational day, the money is devoted to interdenominational work. So far it has been given to the British and Foreign Bible Society. I brought with me fifteen pounds collected in this way for this Society. All the Free Churches are built and supported by the

Colonists, without any external help. Sunday Schools are attached to all these churches and Scriptural Exams are held. As an instance of the unity existing among the Free Churches, you will pardon a personal reference. When my intention to leave the Colony was made known, my Church decided to get up a testimonial for their pastor, but other churches wrote to the local paper requesting the church to make it an interdenominational affair, as all the churches laid claim to me. This was done, and the handsome sum of $1136.00 and an address was presented to me at the central town of Gaiman.

Besides the Free Churches, there are also two Episcopalian churches (one of Moriah, and one gone to Canada) with two ministers supported partly by the South American Ministry, and partly by subscriptions raised in Great Britain. Needless to add that these churches are poorly attended. There is one Roman Catholic Church, maintained by the Government for the use especially of the officials and trades-people of Latin descent.

The population of the Colony is between three thousand and four thousand souls, and you will agree with me that it is exceptionally well provided with places of worship.

The people of Chupat enjoy absolute religious liberty, far more than in this Country. The law regulating marriages is a perfect model of fair play. All religions are treated alike, and no favor shown to any, not even to Roman Catholicism which is the established religion of the Republic. Anyone may bury in any cemetery if he pays for the grave, and no narrow-minded vicar or

curate is permitted to harrow the stricken hearts of mourners at the most distressing moments of life.

A lieutenant on a British man-o-war on a visit to our port died. The nearest burial ground belonged to a Congregational Church. The Captain applied for a grave and got it. He then asked if the chaplain might come and conduct the service, as the departed belonged to the Church of England. "Certainly," was the reply. "Another favor" said the Captain, "he was a soldier, may we bring the band to play the Dead March and give him all the military honors the law permits?" The reply was, "Here is the grave, it is yours, and you may bury your dead in the way you like."

By way of contrast, let me give another story. Shortly after our return to Wales, I was refused burial for the remains of my boy in the churchyard where the dust of my kinsfolk lay. "I should like to bury him there", said his mother, "that his grandmother may take his hand on the Resurrection Morning." "You shall not bury him here," said the vicar. Why not? Because I had wanted a Baptist Minister to officiate. And as a result, my son's remains lie amongst strangers. The vicar that refused my request continues to tyrannize over Margam Parish. We shout, "Britons never shall be slaves!" When, in Gods name then, shall we ever be free?

I got the following story from a respectable captain of one of our liners. A doctor had died on board a British man-o-war on the South American Station, off the coast of Uruguay. They steamed into port and sought permission to bury. A bishop peremptory refused permission to bury a Protestant in the burial ground. The Captain wired to the Dictator in Montevideo requesting his permission, which was immediately

granted. The bishop, however, paid no heed to it, and refused entrance to the ground. The Captain again wired to the Dictator, "Bishop persists in opposition, what shall we do?" The Dictator wired back, "Shoot the bishop, and bury the man." The bishop's opposition collapsed.

The pranks that you allow the minions of Medieval bigotry to play on you in Great Britain are not allowed among men who know what liberty means, and love it.

We are hoping for great things in South America, from the sturdy free churchmen of Patagonia. We have had visions of the future, when children born and bred in the Puritan homes of the Welsh, and well able to speak the language and understand the customs of the people, will be carrying the glad tidings of the gospel to the dark places of the South American continent, and leading its inhabitants to the light and love of Jesus Christ. Already the eyes of the Republic are upon Chupat, and the papers praise the people for their industry, their simple and peaceful habits, and orderly local government. They hold the settlement up as a model Colony for others to imitate.

Addison quotes a Persian fable: "A drop of water fell out of the cloud into the sea, and finding itself lost in such an immensity of fluid matter, broke out into the following reflection, 'Alas! What an insignificant creature am I in this prodigious ocean of waters; my existence is of no concern to the Universe; I am reduced to a kind of nothing, and I am less than the least of the works of God!' It so happened that an oyster, who lay in the neighborhood of this drop, chanced to gape and swallow it up in the midst of its humble soliloquy. The Drop, says the fable, lay a great while hardening in the

shell, till by degrees it ripened into a Pearl, which falling into the hands of a diver, after a long series of adventure, is at present that famous Pearl which is fixed on the top of the Persian Diadem." *Morley's Spectator, p. 421.*

The Welsh Colony of Chupat is but a handful of people amid the many millions of South America. Only a drop fallen into that dark ocean of human lives. But it was dropped there by an over-ruling Providence; already it is within the constitution of the Argentine Republic. It is there. It will remain there. It will solidify and ripen, and in the process of time, we firmly believe, will become the choicest, fairest jewel that shall lend grace to the diadem that the Argentine Republic shall one day wear.

W.C.R.

1989, the Baptist Church in Trelew honored Rev W.C.Rhys with a plaque. He was the pastor of the first built Baptist Church in Patagonia.(Second Baptist pastor to come to the Colony) Uncovering the plaque are, at right, his first granddaughter (Edith), at left his first great granddaughter (Nidia), center his first Argentine great-granddaughter (Karen).

Two of his great-grandsons, Hector and Carlos Rhys, beneath the plaque.

Representatives of all churches offered this testimonial to Rev. W. Casnodyn Rhys, May 1893.

Translation to English:

A recognition presented with a purse of $1136 to the Reverend W.C. Rhys, on the 22nd of May, 1883 in a meeting of the Welsh Colony in Patagonia.

Dear Sir:

In your academic career you won fame and the respect, honor and trust of your teachers and your fellow students: A priceless reward for the student.

In the spring of a social movement of which the world saw no comparison, there opened for you in Britain the attractive fields of the literary man, the poet, the patriot, the lover of humankind and the evangelist; a time when our nation debated that the regrowth of its locks was a sign of recovery of the strength to accomplish brave deeds, yes, a time when the leaders heard the whispering of encouragement of the national resurgence that has already astonished the British Empire. At this time, soon after you put on the armor and to the sorrow and disappointment of many, you had to retire (resign) to seek the recovery of your health.

You were invited to serve your brethren on the banks of the Chubut in the Welsh Colony. You accepted. They will tell how loyal, diligent and successful you were. We declare that your colonial period - a period of fourteen years - is a clear testimony of devotion, taking no account of toil nor sacrifice in order to advance your fellow countrymen in the Camwy.

You took a leading part with temperance, education, political education and literature, with everything that prepared the children of the Welsh in Camwy to take a prominent part in the civilization of South America.

And now in the reviewing of the complexity of the circumstances of your personal, social and family life, you came to the decision that your duty was to return. It is not for us to hinder your departure nor to invite you back. Oblivion shall not keep us asunder. It will be a great disappointment to us if the practice you had here did not sharpen and brighten your arms and develop in you the resources necessary to occupy the front line in the battle - in the great Welsh movement- the civilizing movement of the Son of Man, friend of the poor, defender of the charitable, Lord of true freedom.

May the Lord guide you. May you be given an open door, sight, mind and heart to recognize your ministry and strength to fulfill it. May the One who can reveal himself strongly on your side, have a faithful intervention in the future.

May the blessing of the Lord follow with you, and with your dear and faithful wife and children. May you both see the realization of your best hopes for them.

(This is a revised translation of the original, written in welsh)

Trelew is one of the few cities in the world that exposes the Decalogue as a public monument. The City Committee had grandchildren of W.C.R as members. Posing: Two of his grandchildren (Lesta Olwen and David Hall)

Chapter 17

A Clandestine Seal Hunt in Argentina

By the Rev. W.C. Rhys (late of Patagonia) [1]

On Guy Fawkes' [2] day nine years ago a small crew of fifteen, ignoring Argentine law and license, ventured in a little sailing ship from a small Patagonian port to the seal-covered islets and rocks lying in its vicinity. Interviewing one of the party, a truthful and intelligent man, after their return, he gave me in substance the following account of the expedition.

We had not sailed far when the olfactory nerves, quite as much as the optical ones, informed us of our proximity to Hidden Islet, probably the most valuable fur seal resort of its size in South America.

The sea around the island teemed with these interesting mammalia. They thronged around us as we paddled our boat from the ship to the island, dashing and peering in a most inquisitive fashion. Taking a hurried glance, they would then dive, to reappear again and again for further scrutiny. But the beachless rock-bound coast of the islet soon demanded all our attention, and presented a real and formidable obstruction. It was with considerable difficulty and at great risk of life that a landing was effected.

We had come at the best time, as the breeding had just begun - only five little ones were to be seen. Leaving

three men, with sufficient provisions, etc., to carry on operations here, we set sail again, steering for Race Island, which lies some one hundred miles farther south, and some fifteen miles from the mainland. A very strong current swirls around this island, to which circumstance it undoubtedly owes its galloping name. Race is a small island with a peculiar shape, somewhat resembling the figure eight.

Having got all requisites put ashore, the ship, with a crew of three or four, steered for Egg Harbour on the mainland. A suitable camping place was our first quest, and finding vestiges of an old camp in a sheltered gully, we pitched our tent therein.

From the top of this gully we got a full view of the island and its inhabitants. A view of its kind can never be forgotten. The whole island was almost covered with seals, and from a distance it had the appearance of being carpeted with palpitating skins, glinting in the sunlight. But the uproar was deafening. The whole community was in a chronic state of agitation, unrest, and combat. Argentina succeeds in inoculating even her aquatic subjects with a *penchant* for revolution. The dams and little ones bleat like ewes and lambs, and the males roar like lions; and the old rock vomits again the babel sounds in deep reverberating groans, like a huge monster of the deep afflicted with a nightmare.

This island was to be our home for many weeks. But how could we endure it? The atmosphere was charged with the most sickening odour, giving its taste to every morsel of food, to every drop of water. But Dame Nature is very lenient and is a rare instructress. We soon learnt to eat well in spite of the odour and to sleep soundly in spite of the din. Many an hour did I while

away watching the habits of seals. Each wave brought some ashore and carried others away. There was skirmishing here and dueling there, and jealously everywhere. But through it all, like streaks of silver and gold, were observable the studied and spontaneous maneuvers of devotion, the freaks and pranks of affection, and the young gamboling and frolicking on the rock, like lambkins on the daisied meadow.

Could Cousin Jonathan but have "guessed" at some contrivance for tugging this island with its inhabitants, ourselves included of course, to Chicago, it would have stood second to none of the big shows of that famous fair.

The friction caused by the coming and going of seals for ages had made the declivitous portions of the rock as slippery as sheets of ice, and we soon learnt to walk circumspectly. One of us stumbled and fell, and we stood horrified looking at him slipping helplessly towards the sea. He managed to stay himself when his feet had almost reached the brink.

We found on Race both groups, hair seals and fur seals, the hair group predominating. The hair seal is much bigger than the fur seal, and is generally called the sea-lion. Having no legs, the "flappers" stand them in good stead. In the water they serve as fins; on the slippery rock they serve as suckers wherewith to cling firmly; and on land they serve as legs for creditably expeditious progression.

The community was divided into four distinct classes: 1. The rookery, or breeding ground, where the full-grown males keep well fenced within a circle the females and young ones of the season. 2. Some

distance apart, in a separate group, were the young males from one year old up to seven; those below seven are not admitted into the rookery. 3. The fur seals formed a group by themselves, and did not seem to have come for reproductive purposes. 4. On the western extremity was what we may call the hospital, where the old, maimed, infirm, and weak were gathered together; having withdrawn - or more likely perhaps- been driven on one side in the battle of life by the hale and strong. They appeared like so many human lepers isolated from society. They were at peace, and kept together maybe for the solace of mutual sympathy. I saw only males in the hospital, and inferred that females are permitted to remain through life unmolested in the rookery.

Many instances of strong affection came under our notice. Having stunned or killed a female, the male would sometimes make a rush and bear her away to the sea. We once noticed a male swimming about for days with a strange burden in his mouth. At length he came ashore, apparently to rest. Eager to solve the mystery, we shot him, and were astonished to find he had been constantly carrying about the carcass of his mate.

Attacking the females is difficult, dangerous, and very disagreeable work. First, you have to count with the males all around them; these will attack, and woe to him who gets caught in their jaws. The lions are not easy to dispatch, even with bullets, and their hard, thick and scarred skin is of little value. Then you had to count with the little ones, a still worse affair because of the revolting cruelty practised. Like innocent lambs they would come bleating and pushing about our feet, and would then get clubbed and flung aside-a treatment less cruel, perhaps, than leaving them to linger to death for want of the dam's milk. Sometimes while in the act of

skinning; the animal, which we thought dead, would suddenly revive, and with a portion of its skin flapping loose, would dash away into the sea.

Seals are remarkably tenacious of life. While skinning, as the knife came to the armpits and like tender portions, we would often notice twitching and sharp spasmodic contractions. There was no help for it; the flaying had to be done as quickly as possible, as the fur comes off if the skin gets too cold before being put in salt.

The strength of the sea-lion is marvelous. We threw a lasso an inch thick around the neck of one; eight of us held to the lasso, yet he took us towards the sea with ease. We passed the lasso round a projecting piece of rock, but it snapped at the fulcrum like tow, and the brute escaped with the remaining piece round his neck.

Seal-hunting is generally well spiced with adventure. We had some hairbreadth escapes. Going out one day with fowling-piece in hand to shoot some gulls, as I doubled one of the numerous ravines I observed a sea-lion apparently asleep. I stood some six feet above his head. Thinking the fowling-piece would kill at such short range, I fired, and the beast stretched and lay still. Having entered the gully lower down, I was walking up the slippery bottom when my companions shouted "Look out, he is alive!" He was making for me with mouth wide open. I was fairly caught in a trap, and escape was impossible, for on both sides the rocks rose perpendicularly, barely three feet apart; the gun was empty and nothing could stop the brute's mad rush for the ocean. How I wished it were possible to give him elbow room!

I raised the gun, intending to thrust the barrel down his throat, an easy thing it seemed, as his mouth yawned like an open sepulchre. But the jaws slammed shut with lightning speed, catching the barrel between the teeth. I held by the stock for dear life, and the beast still came on munching the barrel, and bringing his jaws nearer the stock, and pushing me nearer the deep. His warm breath was already on my hand when I fell in the scuffle; and he, dropping the barrel, plunged his teeth into the thick hempen sole of my slipper. Disgusted, apparently, with the unsavoury quality of his antagonist's parts, he relinquished his hold on my slipper just before taking his plunge, leaving me saved on the brink! I was very little the worse for the encounter. He had marked the whole length of the barrel, and had left a broken tooth in the sole of my slipper. Did I owe my narrow escape to the breaking of this tooth?

Before leaving the island we had an adventure which seldom falls to the lot of even a sealer, and which, I sincerely trust, will never be repeated in my experience.

On our last Sunday there it commenced to blow a very stiff breeze, but we turned into our beds at night apprehensive of nothing unusual. About four o'clock in the morning we were startled by finding the tide actually coming into our tent. Everything had to be instantly taken to higher ground. When it was sufficiently light, we saw the spot where we had slept secure for so many weeks completely submerged. Looking around we found that the island was becoming a little thing; the angry sea already swept over most of it.

Monday was a fearful day-it kept blowing a terrific gale. The sea around was one mass of scudding mountains and resonant valleys. They bore down upon us, mountain chasing valley, and valley urging mountain. We are lost! No; for the plunging mountains melted into plains of foam as they touched the rock, and spitting on us in baffled rage, retreated. We gain confidence and view with more composure the magnificent array of each successive phalanx hurled upon us by frantic Neptune. All around is one vast boiling caldron, and water is converted into hissing foam and blinding spray. The steadily diminishing island broke at length the spell of the wild scenery.

A fresh thought brought home with staggering force the danger we were in; a remark was made that nowhere on the island had we seen the least vegetation. Everyone echoed the remark, and involuntarily looked around. We occupied the highest ground; but not a shrub, not a blade, not a fibre of a root could anywhere be seen The truth flashed upon our mind-the island is occasionally submerged! Then came the inevitable inference that such an occasion was now upon us. We looked into each other's eyes and read despair; a few hours and we should all be whelmed and whipped away. Then came bitter reflections and self-reproach. Our hands were red with the blood of innocent creatures, upon whom we had pounced with reckless cruelty in their most interesting season. We had barbarously dashed out the brains of their little ones, or left them to perish from starvation. We had surprised the mothers as they came to suckle their young, and stripped off their skins. We had seen our victims quiver at each move of the blade. Horrible butchery! But it is the true price of the sealskin jacket!

Surely the waves were sentient, and had come to avenge the wrongs of those nursed on their bosom. The spirits of the deep were stirred, and were clamant for reprisals. How I hated the whole business! This was my first sealing venture, and, if spared, it would be my last.

On Monday night the wind abated, and we breathed more freely as hope returned. Tuesday the storm still subsided, and we kept an anxious look-out for our ship. It arrived not, and night came on with its need of discomfort. We fully expected to see her early in the morning. But when the morning had come, as hour after hour passed away and nothing could be seen of her, we begun to fear she had gone down in the storm. Had she weathered the gale all right, we felt sure she would have come to us ere this. Again our hearts failed within us. Verily we were doomed men -doomed to perish miserably on this lonely rock in the ocean. It would not occur to any to come searching for us, till we had long been dead. The island was well out of the course of all trading vessels, and it was most improbable that any ship would chance to come near enough to be sighted and signaled to.

But the unexpected always happens. On this same Wednesday we beheld a strange ship making for our rock. Our hearts leaped within us at the sight. It was the British yacht *Marchesa*, in which Lord Dudley was making a trip round the globe. Our own ship, we were told, had been driven ashore in the gale on Monday. Lord Dudley having run for shelter into the bay where our ship was stranded, was told of our situation, and came to see how we had fared. He took us away and exerted himself in getting our craft to float again. He took inmense pains with us, the hawser snapping several times as the *Marchesa* tugged away at our

stranded ship. But like a true Englishman, he persevered till it was got to float once more. Then amidst warm demonstrations of sincere gratitude, this most opportune angel of mercy, the beautiful *Marchesa,* steamed away for the Falkland Islands. Our own vessel being in no wise damaged, we set sail for the island, and took on board there the skins and oil we had accumulated.

We then steered for Hidden Islet, to take up our friends left there. Thence we steered for the port of embarkation, dropping anchor on February 20, 1886. Our booty consisted of one thousand five hundred sealskins, beside a quantity of oil.

[1] Article written by W.C. Rhys, published by the magazine *The Boy's Own Paper*, January-March edition, 1895. It puts in evidence the concern of the author toward environmental defense of the Patagonian fauna.

2 Guy Fawkes was executed in 1605 due to his attempt to destroy the English Parliament.

Part of the shore in Peninsula Valdes became a macabre ossuary because of the pirate commerce of sealskins. Rev Rhys used his pen to denounce this destruction of wildlife and environment. Now the Province of Chubut has strict regulations defending its sea life. Also its National Parks are preserving its natural environment

Sea Elephant

A group of young male sea lions (otaria flavensis) near Port Rawson.

Thousands of penguins (sphenicus magallanicus) nest in spring in Tombo Point, Chubut

APPENDIX 1

Olwen Leonie's Recollections of Stories About her Grandfather

As told by her Father, R. Dochan Rhys

William Casnodyn Rhys, even as a young man showed baldness, with a magnificent Calvin beard, a high forehead with deep set eyes. He had no singing voice, being sent away from Sunday glees around the family harmonium; but he had a wonderful speaking voice and a fine preaching style. Tall and dignified, scholarly and unworldly, generous to a fault.

His adventures were wonderful, as told by my Dad. Once he was benighted on the prairie and sprayed by a skunk on the bridge though his horse, Kitty, had balked and danced and tried to stop him from crossing. When his wife smelt him coming, she stopped him and would not let him in the house until he had washed completely in the yard.

His favorite horse was a pure black stallion called Corban. It was very strong, Dad claimed that like Dick Turpin of old, Granddad had ridden a hundred miles in a day and a night on him. The stallion was not however good at stud and only sired one foal like him, coal black. When a cougar carried it away one night, William did a foolish thing and followed it. Fortunately, he did not catch up with it.

The passage through the Cordilleras was a mighty undertaking. He steered by his chronometer and named one of the lakes, Lake Chronometer. Granddad is said

to have come across a petrified forest, where the vibrations of a loud sound was enough to send some trees crashing. His party would keep still until all was silent again, before advancing.

On another occasion, while in the high Cordilleras, a cougar, awakened by their passage, attacked the horse in front, and Grandfather managed to shoot the beast, and not the horse and rider. Dad said also that he had shot a rattlesnake in the yard where one of his baby daughters was digging with a wooden spoon. He was a remarkable shot.

W.C.R.

APPENDIX 2

The Eisteddfod In Chubut

by Clydwyn Ap Aeron Jones[*]

In 1865 families from South and North Wales, from cities in England, and even from the United States of America, migrated to Argentina seeking a better life.

The contacts with Argentina began in 1862 when some selected envoys searched un-colonized regions of this South American Republic. It should satisfy the aspirations and interests of Welsh groups who were suffering government tributary pressures, years of poverty because of crop failures, ever higher rental payments, intense desire to profess church liberties, and all this stimulated by the historical emigration tradition of their Celtic ancestors. So, three years later we find a group of one hundred and fifty three persons boarding the *Mimosa* in Liverpool headed for the long trip to the desolate coast of Patagonia.

In Wales itself and in the Welsh colonies of the United States they promoted the excellence of the zone, stating that "the climate is very healthy, the soil is fertile, with great advantages for colonization, no settlements near, only nomad Indians." Many were enthused with the project and in July 28, 1865, the first group disembarked in Bahía Nueva (New Bay), in what is now Port Madryn. The trip might be termed difficult and hazardous, but more so were the first years on the new lands. Explorations were difficult because of the cold climate, there was a lack of basic resources, fear of Indians, encounters with wild animals, repeated loss of

provisions; these were some of the vicissitudes suffered by the pioneers in their efforts to colonize.

The respect for the nationality of the new land, both friendly and savage, that was welcoming them, was mixed with the remembrance and love for the country they were leaving. But their valued experience was transmitted by word and letter to their relatives and friends, and soon we see new groups arriving with their furniture, their utensils, their Bibles and hymnbooks, their harmoniums and organs -- Welsh love music and make it and take it with them wherever they go.

We come finally to that strange word -- ***Eisteddfod.***

The Eisteddfod is a contest, a competition, similar to the Flower Games but with a much earlier origin; so old that its celebration can be traced back to the sixth century of our era. It is clear therefore that it originated long before the competitions that began in Provenza, France, in the twelfth century. The Welsh word "Eisteddfod" derives from the verb "eistedd" that means *sitting,* and "fod", *to be.* So Eisteddfod is *to be sitting.* This comes from the requirement of all poets to be seated when they were in the meeting where the winner of the *poetic contest* was to be determined, so that when the winner's name (pseudonymous) was called, the only one to stand would be the winner, so that everyone could see him. The winner then was led to the stage by two members of the Circle of the Bards to participate in the ceremony.

The priestly corporations in primitive Gaul, Wales, and Ireland, are still alive in literature of the Christian era. The druids conducted their get-togethers in the same fashion as in the pre-Roman world. The tradition for

reciting poems in literary meetings has maintained its strength up to the present through the bards who have protected and spread ancestral values that date to the dawn of the arts.

Little by little, music and choirs made their way into the competitions because they considered it important to preserve and prolong the tradition well earned by Wales. Precisely in Wales there is an Eisteddfod that is exclusively musical, it was born in Llangollen, North Wales, in 1947--the year World War II ended. This festival has a motto that tells you all: *"Blessed is the world that sings; how sweet are its songs! May the voices of its choirs silence the cannons forever!"*

In the Chubut Valley the first Eisteddfod took place in 1875, in a small meeting place constructed with the boards salvaged from an old shipwreck that lay on the shore near Rawson. There the group sang, recited, danced and reminisced their *old and beloved country*.

During the first years of consolidation of the groups, regardless of the adversity that they had to confront, the Settlers celebrated new competitions every year, maintaining the tradition of their "Old Wales".

In the nineteen-forties, the Eisteddfod began to include presentations in the Spanish language. The descendants of the first Settlers could no longer maintain a linguistic isolation, not even in the Eisteddfods, even considering that in its prime objectives they wished to uphold Welsh language and traditions. In a short time, the two languages have come to share equally and fuse perfectly.

Today the Eisteddfod is one of the typical festivals of the Chubut Province that became part of us through the immigrants from Wales. It congregates around the arts all that nurture in their lives the sense of freedom, solidarity, and respect for peaceful and convivial living.

Every contest constitutes, not a battle for a prize, but an opportunity to learn and enjoy the sharing of an enriching experience. The participation in these competitions is open to every person and group that seeks it, for no one is specifically invited to participate, but all are welcome.

Ms. Arnold from Trelew speaks to the Patagonia Club with representatives of the Welsh Colony. Porthmadoc Eisteddfod, Wales, 1987.

The organizing committee does not pursue financial gain and the festivals are financed by public and private donations, and by the fees from ticket sales. The Eisteddfod always can count on the altruistic contribution of the juries, that do more than just assign distinctions, they evaluate the work of the participants, indicating their abilities and skills, showing possible errors, all for the improving and self-betterment of the participant. The jurors, changed periodically, offer also a variety of perspectives in their appreciations, as correspond to the relativity of human judgments. In

this way, the festival is a result of the plural contribution of all.

Those that participate in the celebration grasp the possibility of manifesting the values that ennoble and dignify our lives. It further contributes to promote mutual understanding and international Peace through the universal language of music, poetry, and dance. As recognized, this minimizes the differences between Nations and unites thousands of hearts in a joyful harmony.

In 1975, one hundred and ten years after the arrival of the first contingent of Welsh, the "Red Dragon" of Wales is hoisted together with the Argentine flag. This commemorative pyramid has inscriptions in Spanish, Welsh and English (Trelew, Chubut)

* **About the Author:**

Clydwyn Ap Aeron Jones was born in Chubut. He studied in the English Intermediate School in Gaiman. Later he graduated from the National Conservatory of Music in Buenos Aires. The British Council awarded him a Scholarship for the University of London where he studied Methodology and Choral Direction and received his Master's degree in Music.

He was accepted by contest to the Circle of Bards in Wales, where he acted as Juror in the National Eisteddfod. He integrated many examination committees such as Teachers Congress in Rome, the Examination Committee for the Argentine Secretary of State and others. He is the founder of three choirs in Buenos Aires and two in Chubut: the National University of Patagonia, and the Higher School of Music of Chubut.

Distinction Awards: Gold plaque from Channel 7 of Buenos Aires, silver Condor of the Province of Buenos Aires. He is also a member of the National Academy of Fine Arts.

He lives with his wife, Alicia, in Port Madryn, Chubut. One of his latest distinctions was the First Prize in the Chubut Eisteddfod for his sonnet *"Cwm Hyfryd"*. As Wm. Casnodyn Rhys received from the Argentine Government half a league of land in this beautiful Andean Valley, Cwm Hyfryd is an appropriate ending for these *Patagonian Memories*.

Here is the Welsh original with its English free translation:

CWM HYFRYD

Cwm Hyfryd yw
enw y dyffryn draw
Rhwng uchel fynyddau yr Andes Fawr
Amrywiol belydrau'r heulwen ddaw
I liwio'r olygfa ar ddydd a gwawr.

Caniad yr adar ddaw'n hyfryd ei sain,
Swyn yr awelon yn serchu pob llwyn
Nentydd y mynydd yn groyw a chain,
Ffrydiau eu dyfroedd yn fywiol a mwyn

Gwelodd y Cymry brydferthwch y fan
A seliwyd eu bwriad dan nawdd y Ne'
Gan feithryn sefydliad, ysgol a llan

Dan gysgod y wybren a Chroes y De.
Cariad at Dduwdod, ffyddiog obeithion,
Lloches rhinweddau enaid a chalon

BEAUTIFUL VALLEY

Beautiful Valley they called
that faraway site,
'Twixt snow-white peaks in
the Majestic Andes.
Intertwined are the complex
rays of light,
That flood with bright color
the landscape of dawn.

The birds' joyful songs give
sweetest delight,
The charm of the breeze
brings life to the brush.
Murmurs of mountain
springs tempering their tone,
Awaken with music their
lives and their love.

The beautiful valley
impacted the Welsh
Sealed was their will, neath
heaven's protection...
Here, home they *must* make,
with chapels and schools.

For canopy, blue skies;
Southern Cross as a guard.
The Almighty's love, giving
faith, giving hope.
A sure refuge for virtue, for
heart, and for soul

Professors Alicia and Clyndwyn ap Aeron Jones uphold the traditions.

The traditional Eisteddfod is still celebrated in tents in rural districts. This picture shows the one in Dolavon, Chubut, 1933. (Photo Stillitani)

One of the 'four generation groups' attending the Gymanfa was the Rhys family. Taid Rees (center front), originally from Patagonia but now living in California, presides over his clan. The North American Festival of Wales 2004, Ninnau, October 2004